HOMEWARD

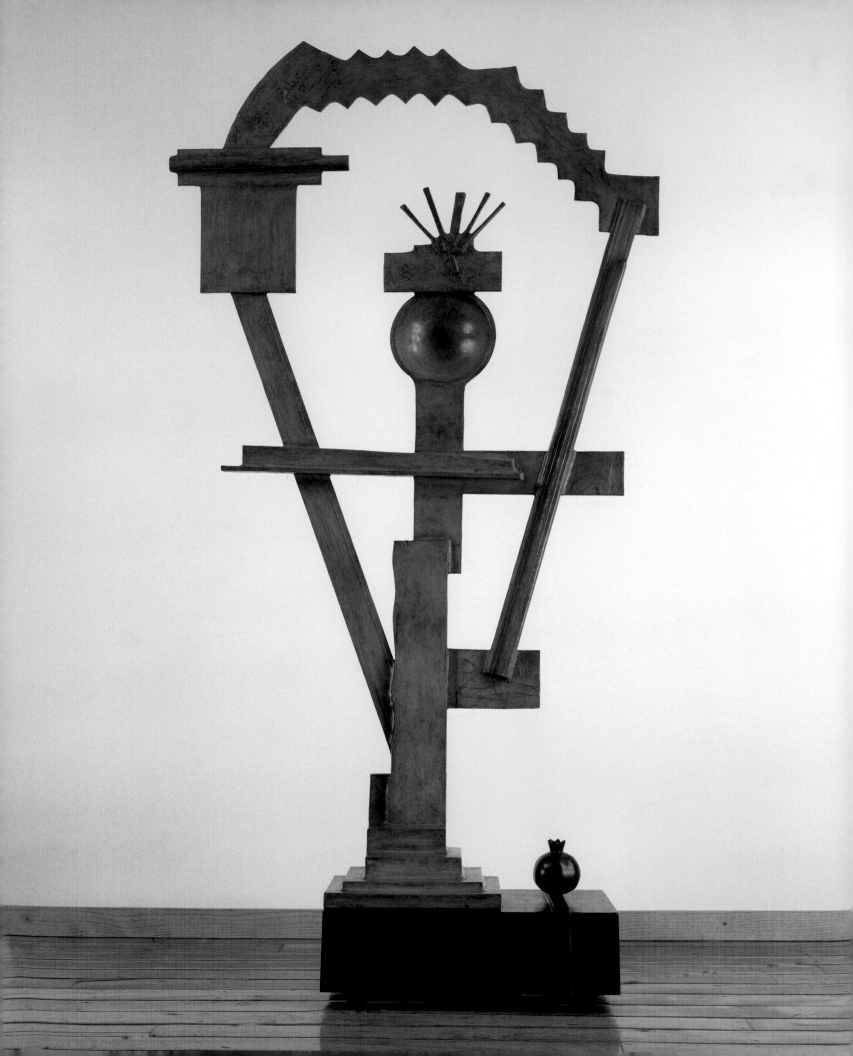

HOMEWARD

BAGHDAD | JERUSALEM | NEW YORK

SCULPTURE

OF

| MARIUS KWINT | MICHAËL J. AMY | DONALD KUSPIT | ESTHER COHEN |

sundaram tagore gallery

Mapin Publishing

in association with

First published in the
United States of America in 2004 by
Sundaram Tagore Gallery
137 Green Street New York, NY 10012
Tel: (212) 677-4520 • Fax: (212) 677-4521
email: gallery@sundaramtagore.com

in association with

Mapin Publishing Pvt. Ltd.
Ahmedabad 380013 India
Tel: 91-79-755-1833 / 755-1793 • Fax: 755-0955
email: mapin@icenet.net • www.mapinpub.com
and
Grantha Corporation
77 Daniele Drive, Hidden Meadows
Ocean Township, NJ 07712
email: mapinpub@aol.com

Distributed in North America by
Antique Collectors' Club
91 Market Street Industrial Park
Wappingers' Falls, NY 12590
Tel: 800-252-5231 • Fax: 845-297-0068
email: info@antiquecc.com • www.antiquecc.com

Distributed in the United Kingdom & Europe by
Art Books International Ltd.
Unit 007 The Chandlery
50 Westminster Bridge Road
London SE1 7QY UK
Tel / Fax: 020-7953-8290
email: sales@art-bks.com • www.artbooksinternational.co.uk

Distributed in Asia by
Nickleodeon Books Pte. Ltd.
80 Genting Lane, #07-04 Ruby Industrial Complex
Singapore 349 565
Tel: 65-6338-5924 / 6338-3740 • Fax: 6338-4213
email: shafinah@singnet.com.sg

Text © Sundaram Tagore Gallery and Oded Halahmy
Photographs © as listed
Photographs by Oded Halahmy,
Georgina Bedrosian, James Dee & Steven Lopez

ISBN: 81-88204-29-3 (Mapin)
ISBN: 1-890206-65-2 (Grantha)
LC: 2003-109669

Compiled by Faina Goldstein
Design by Jalp Lakhia / Mapin Design Studio
Processed by Reproscan, Mumbai
Printed by Tien Wah Press, Singapore

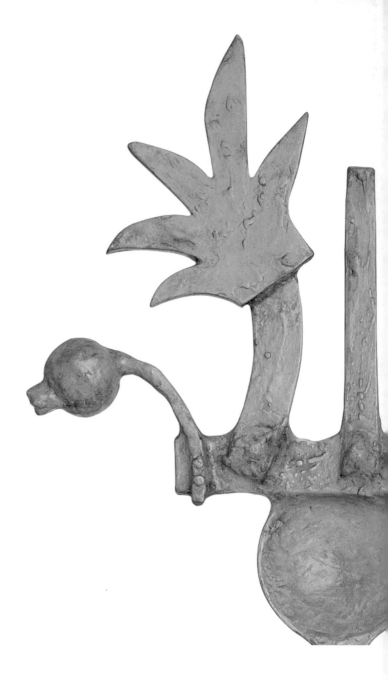

Page 2

Babylonian River Banks 1989 Bronze Cast.
H 96" W 49" D 17" (244 x 124 x 44 cm)
Sculpture No.186 (ED 3)

Above

Detail of **City in Bloom** *page 106*

Sundaram Tagore Gallery is an international gallery that is mainly devoted to examining the confluence of Western and non-Western cultures. We are committed to developing exhibitions of intellectual rigor, and showcasing artists who are engaged in spiritual, social, and aesthetic dialogues with traditions other than their own. In a world where communication is instant and cultures are colliding and melding as never before, our hope is to create an appreciative audience for art that transcends boundaries of all sorts. Our interest in cross-cultural dialogues extends beyond the traditional visual arts into many other disciplines, including poetry, literature, performance art, film, and music.

Dedicated to my father
Salech Haskel Chebbazah

During the 1950s I was sculpting in a figurative style and living in Ramat Gan, Israel. I asked my father, "What do you think of my sculpture?" He said, "If we were still living in Baghdad, I would cast all of your sculptures in pure gold."

My father was a goldsmith. He was pure gold, tested by fire. His unconditional love and his trust in my vision enriched my life.

Acknowledgments

Grigory Abel

Wynn & Larry Aldrich

Carol Anderson

Florence Aronowitz

Georgina Bedrosian

Esther & Ralph Bortman

Esther Cohen

Eve Caligor, MD &
 Michael W. Blumenstein

Vivienne Roumani-Denn

Claire Figueroa

Regine Ginsberg

John & Alice Goldsmith

Dorothy Greenstein

Jean Grestell

Ahuva & Haskel Halahmy

Eleanor Heartney

Miriam & Rafael Halahmy

Sylvia A. Herskowitz

Milly & Herb Iris

Gerrit Henry

Raman & Vinita Kapur

Donald Kuspit

Stephanie Later

Ren'ee & Philippe Levi

Leslie & Mitchell Nelson

Linden & Michelle Nelson

William & Rachel Meer

Susan, Louis & Ari Meisel

Leon & Joan Meyers

Sydney Millgrim

Aaron Miller

Michele Mosko Miller

Mr. & Mrs. Ted Millon

Ralf & Sylvia Milrod

S. David Moche &
 Nancy Wolfson

Marc Mollery

Robert S. Moor

Walter Moos

Lucill & Brian Murray

Carol Olwell

Michael & Scarlet Pildes

Luke Peterson

Edith S. Peiser

Yvette Raby

Horace Richter

Viri Salvador

Eliezer Saraf

Albert Serry

Leyn Schroder

Alfred & Hanina Shasha

Dennis & Karen Shasha

Ellen & Robert Shasha

Frederick &
 Elizabeth Singer

Lynn & Jeffrey Slutsky

Michael Spett

Donald Steel

Jill Sullivan

Sundaram Tagore

Seran & Ravi Trehan

Justine Truger

Ruth & Fred Weiss

Reba Wulkan

Eva Zetlin

Raymond Zimmerman

Contents

Preface Oded Halahmy 9

Homes of the Pomengranate Esther Cohen 17

Meeting Oded Halahmy Marius Kwint 22

**Oded Halahmy's Sculpture
Defies Easy Categorization** Michaël J. Amy 33

Oded Halahmy: Modernist Sculpture Donald Kuspit 42

Chronology 128

Preface

I was born in the old city of Baghdad in 1938. We lived near Elshorjah, a fruit and vegetable market not far from a coffee/teahouse that I visited with my father. Some evenings, he would take me with him to sit, drink tea, and play *Shish Besh,* or watch others play their games. I liked listening to the discussions on public events. My father usually listened, but sometimes he made a small profound remark. He was successful in many ways, so people valued his opinion. He was always honest and generous with his kind words. The coffee house was on Gazy Street. My father would carry watermelon seeds and a pocket flask full of *Arak* to share with his friends around the table. We lived in a large house, three-stories high with a large courtyard open to the sky. We could play tennis there, or have a live orchestra play. Sometimes we would have private parties for the weddings of close relatives, or to celebrate newborn babies, and we would have Chalghy Baghdad (the Iraqi orchestra) play for our guests. Many guests stayed with us overnight or for as long as they wished. My mother and her maid prepared marvelous Iraqi food that I can still taste in my mouth. One day I would like to write a book about my mother's cooking. In New York City, when I have parties, I seek out Iraqi caterers and think of home. Many of my memories are centered around our wonderful meals.

In the summertime, the entire family would hire a horse and carriage and go to the Tigris river. We had fishermen catch fish for us; they skewered the whole fish and stuck the skewers in the ground over a wood fire they had prepared. This is called *Mezgoff*. We sat by the river, eating our *Mezgoff*, followed by watermelon and other fruits.

In my memories of Baghdad, everything is vivid, beautiful: people, friends, relatives, food, the city and its museums and parks, rivers, and landscapes. For me, it was the most beautiful place on earth, a paradise. I liked my school

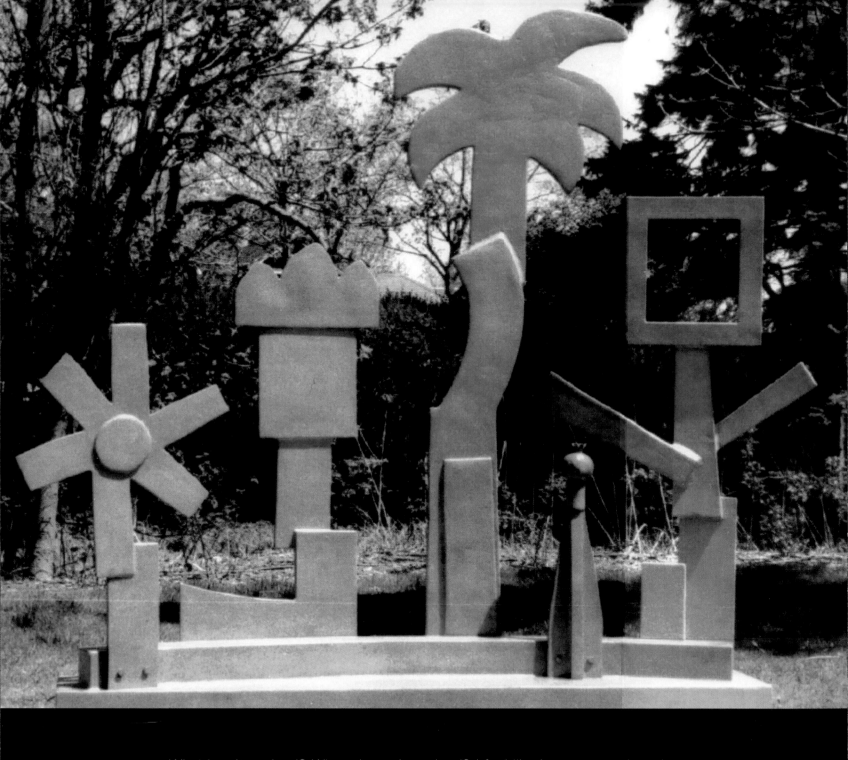

What is a homeland? Where is my homeland? I feel like I am a nomad, and my homeland is the place where I am working and living. The very landscape I sculpt is a statement of my home at peace. All land is holy.

and did very well. I especially liked reading and writing, calligraphy and drawing, painting and crafts. During my lunch break I would go out to the streets, and in summer I liked to have handmade ice cream or flavored ices that were made right in front of you. In the winter I would get boiled fava beans, boiled sweet turnips, or baked beets and turnips, hot in a paper cone. My favorite was the typical pickled mango-and-tomato sandwich (*Samoon*). Sometimes I added shish kebab to it (*Laffa*). I went to the Rachel Shahmoon School until 1950, the year before we immigrated to Israel.

I had a large collection of pigeons. After I had done my homework, I would go up to the roof, where I kept them in a room. I would release them to fly into the sky, and they would not come back until I called them. When they did return, they flew onto our roof and I led them to their room and fed them.

My father, Salech Haskel Chebbazah, owned a goldsmith workshop and was one of the first goldsmiths to introduce metalworking machines, in 1932. Goldsmiths all over Iraq were acquainted with Chebazzah and brought their gold bars to his workshop for cutting and processing. They nicknamed my father Saleh Abu El Maka-In, and the ones who knew him well called him Salech Abu Heskel.

In 1951, we registered in Baghdad to leave for the newly created State of Israel. My father and mother could not sell their property and my father's business and use the money to enjoy the same high standard of living in the new country that we had been accustomed to in Baghdad. We were allowed to take only one suitcase when we left, so we wore our most beautiful suits and dresses and jewelry and left our homeland with deep sadness.

After we landed at the airport in Israel, we were sprayed with DDT as we walked out of the plane, loaded on the back of large flatbed trucks that had no seats, placed in transition camps, and given two tents: one for the men and the other for the women. Harsh winds made the tents fly away. As a child, I remember the cold winter; there was no heat and no running water.

My father could not practice his profession as he had in Baghdad. He did manual labor on the roads, and he made whatever he could do, so the family could survive making very little money. My older brother, Haskel did earn more than my father, by painting lamp posts in the streets! I took care of my little brothers and sisters, attended school, and worked by painting houses, planting lawns, and gardening in the wealthy new houses north of Tel Aviv.

All my family and relatives worked very hard and took their destiny into their

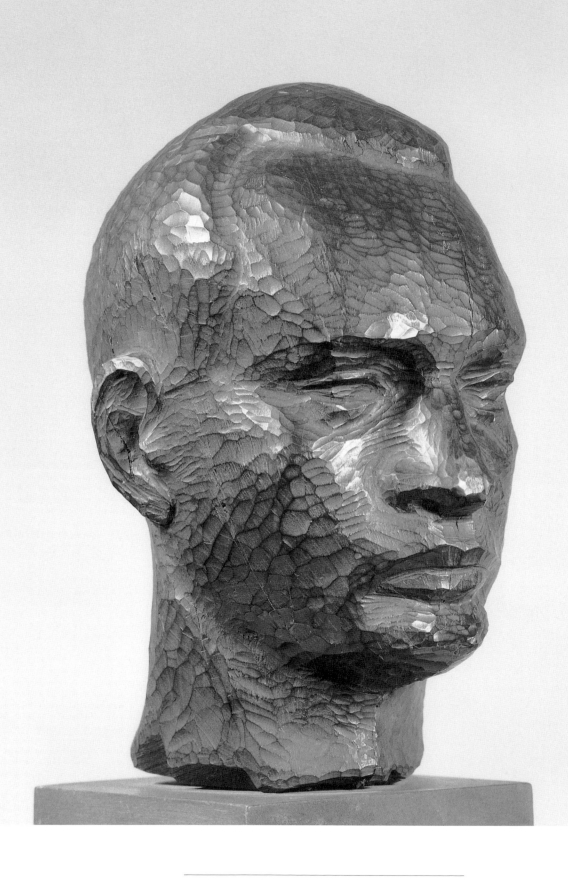

Self Portrait 1964 Cherry Wood. H 17 ½" (44.5 cm)
Sculpture No.13 (Unique)

own hands. We were dedicated to the family and to our new country, which we loved. Eventually, we bought a little house in Jaffa, in an Arab neighborhood. Many of our relatives stayed in the refugee camps after we had left. We could not listen to Arab music in public because the authorities told us that the Arab countries surrounding Israel were our enemies. We listened to Arabic music in secret inside our home, and a few years after settling down, my mother and father went to listen to Iraqi music played by the Iraqi immigrant musicians Saleh and Dahoud Elkuwaity. I studied and worked until I was eighteen, when I was drafted into the army. It was always in my heart to make art. I had painted in Iraq, inspired by Arabic calligraphy, and in Israel I painted and made sculptures whenever I had time.

I was looking and learning, using a variety of different materials in order to discover which media allowed me to express my feelings in the most creative and spontaneous way. I could manipulate clay, wood, plaster, cast cement, and I assembled wood to make satisfying sculptures. Wood is my first love. (I still make all my original pieces in wood, and later the works are cast in bronze or other lasting materials.)

In July 1966, I decided to go abroad and I closed my Tel Aviv studio. I was looking forward to seeing art in the wider world. It was very exciting for me to travel in Europe. In Greece, I felt at home; the architectural sites were truly inspiring. Italy was a love affair. I was working with my eyes all the time, looking and absorbing a new and very different culture. I often returned for the Biennale or just to vacation. In France, I found the most exciting twentieth-century art, and spent a lot of time browsing in antiques shops and galleries, as well as people-watching. Most important, I spent time at the great museums, feeling intimate with the *Mona Lisa* and at home with the superb quality of the Near Eastern art there.

In England, where I settled, the climate was very different from that of the Mediterranean, and I found it both mystical and relaxing. The people were well-mannered, kind, and gentle. Spicy Indian food suited me perfectly. I was also delighted with the live concerts of Indian music and dance. At the theater, I felt that the elaborate spaces, decorations, and special attention to dress were like being in a temple of art. It was here that I discovered Martha Graham. Her dancers were like the movement of sculptures in space. I greatly enjoyed seeing contemporary sculpture and painting in the museums and galleries. The great collections of Near Eastern, Egyptian, and African art at the British

Museum were a home for me. Today, I still have a home to visit in London, with my brother and his loving family.

In the late 1960s, sculpture was big in London, and I met Anthony Caro and other artist-teachers during my postgraduate studies at the St. Martin's School of Art. Henry Moore and Phillip King encouraged me greatly in my new departure in bronze sculpture. Caro felt that bronze was old material, yet casting bronze was always new for me. I wanted to sculpt every single form that I incorporated into my sculptures by hand. I still do. I constructed the sculptures from wood, and they were cast. I used bronze then as I do now.

Toward the end of my studies in England, I met with Henry Moore and we discussed enlarging my work. I had good skills and experience with this, and I noted that sometimes it is necessary to change the work when it is made larger in scale.

In London, I experimented with both pedestal and floor-based sculpture. The electric band saw was a great tool for cutting, as opposed to direct carving. It allowed me to work quickly, to improvise; I took greater risks, and I got results faster. Some pieces were constructed in stacks and opened out. Some were cut from a single block, like totems. I also experimented with fiberglass, cardboard, and other softer materials. Some sculptures were left in the raw; some were painted, like skin. Most of these sculptures were destroyed or recycled. I had to let them go in order to move forward and create a more substantial statement.

Moore offered me a job as an assistant. However, after my studies at St. Martin's I decided to accept a teaching post at the Ontario College of Art in Toronto.

In 1968, while teaching at the Ontario College of Art, I felt that my students should be experimenting with many kinds of different media. I introduced dance, music, video, and photography to the sculpture department and encouraged young artists to use any medium to express themselves rather than follow fashion. This teaching style was new to the college. I believe that when I teach I should always bring out the unique beauty of art and encourage special interests. I am not interested in having my students be influenced by my work. (I always recognize an original artist and have sympathy for his or her struggle.) Students inspire me with their energy.

I myself built several pieces in lightweight, inexpensive materials. They were constructed quickly and painted in satisfying colors. The result was a major

one-man exhibition at the Gallery Moos in Toronto. During this time, I had a breakthrough in my work. This new sculpture was constructed full-size directly in wood or cardboard and then taken to a fabrication shop in Toronto to be finished in metal: stainless steel, aluminum, or bronze. The machine shop was a revelation. The heavy industrial equipment and the skilled assistants there were wonderful. They helped me with assembling, welding, grinding, and finishing. They helped me realize my three-dimensional dreams, and now my work could also stand outdoors. Color was a concern, however I always mixed my own pigments, creating Oriental shades suggested by the foods I like.

My goal is always to create balance, harmony, and peace. The shapes and forms of my work relate to my feelings and experiences in my daily life; it is a record of my progress.

I had always dreamed of America, but I found it to be even bigger and more beautiful than it had been in my dreams. I made several brief visits to this country in 1968, and in 1970 I came to New York City with my students from the Ontario College of Art. I wanted to show them the budding art world downtown, in today's SoHo.

It was a time when Clement Greenberg was promoting Abstract Expressionists: Jackson Pollock, Barnett Newman, and Mark Rothko, and a generation of sculptors that included David Smith and Anthony Caro. In contrast, the innovative art dealer Leo Castelli was promoting the new Pop Art movement; Ivan Karp and Louis Meisel were showing Photorealism. I admired the work of Mark DiSuvero, Willem de Kooning, Andy Warhol, Jean-Michel Basquiat, and Robert Smithson. There was a spirit of playfulness, but it was serious, too. I found New York City exciting and inspirational, tolerant of a variety of ideas, styles, and forms of art. I loved it all.

I was invited to be a guest artist and lecturer at the Cooper Union School of Art, and to be an artist-in-residence at the Parsons School of Design. In March 1971, I moved to New York City and found my SoHo loft. I was one of the pioneers when I moved downtown, south of Houston Street. At that time, SoHo was in transition and consisted primarily of warehouses and manufacturing companies.

America was like nowhere else. I found myself without friends or money, and with all the problems of settling in a foreign land once more. Yet whenever I

needed materials, I always found them. Dumpsters were always filled with remnants from factories and renovations: old furniture, scrap metals, wood, paper, and other materials for my work.

I wanted to have my own space so that I could build it to satisfy my needs. I also acted as a resource person, helping artists and dealers find spaces, inviting uptown dealers to exhibit in the large new downtown galleries. I became the director of 141 Prince Street Gallery, curating exhibitions.

In my loft I began to fulfill my vision of making large-scale sculptures. I made wood pieces directly on the floor, without a formal base. The floor space was like a landscape. I used wood, cardboard, and other found materials. The only limit was the space itself, more than 4,000 square feet, with a nine-foot ceiling and a spacious freight elevator.

I did not know what I would do with these large sculptures. I just had fun making them. I was playing with materials, moving and dancing with forms, like a child. In a way, space produced art. People came. My loft was a mecca for friends who often stayed over, making art, making love, sharing everything I had. My friends became my family.

–Oded Halahmy

Homes of the Pomegranate

"And the pomegranates are in flower: I will give my loves."

Song of Songs 7:14

*"I would lead you and bring you into the house of my mother,
and into the chamber of the one who bore me. I would give you spiced
wine to drink, the juice of my pomegranates."*

Song of Solomon 8:2

*"Let us go out early to the vineyards, and see whether the vines
have budded, whether the grape blossoms have opened
and the pomegranates are in bloom. There I will give you my love."*

Song of Solomon 7:12

*"Your lips are like a crimson thread, and your mouth is lovely.
Your cheeks are like halves of a pomegranate behind your veil."*

Song of Solomon 4:3

*"Your channel is an orchard of pomegranates with all
choicest fruits, henna with nard."*
Song of Solomon 4:13

"A land of wheat, barley, grapes, figs, pomegranates, olives, and dates."

Deuteronomy 8:8

Oded Halahmy loves pomegranates and fills his sculptures and his intimate art objects with their sensuous shapes. Round and full, his pomegranates are an ancient and universal symbol of beauty, love and marriage, fertility, prosperity, hope, life, and rebirth. Their seeds, rich and abundant, promise a generous future.

Halahmy says, "The sensuous red round pomegranates are around me all year long. I have them in my kitchen, my home, and my studio in many shapes, colors, and materials: real dried pomegranates and ones in plaster, bronze, aluminum, silver, and gold. They are my intimate art objects.

"Traditionally, in my home we eat pomegranates on the New Year and we recite, 'We should increase our virtues like the pomegranate seeds.' We hang the pomegranate fruit with other harvest fruits from the sukkah (a symbolic shelter built and used during the Sukkoth, or Feast of Tabernacles, the eight-day harvest celebration). There is nothing in the world more sensuous than pomegranates. They are the jewels of the autumn.

"The exterior of the pomegranate is seductive and tempting, and its round body is full of red or pink seeds. I cannot eat a pomegranate in a rush or as fast as I eat other fruits. You must have a lot of patience, and you must be gentle when you open it. When I am eating a pomegranate I am relaxed. I have all the time in the world. I will give it all the time it needs— like a good relationship, a work of art. When I open a pomegranate, I see all the beautiful secrets within. Beneath the fruit's skin there are the juicy seeds, jewel-like, packed in compartments. I like to bring the whole compartment to my mouth and enjoy a large amount of the fruit. Sometimes I pick out the seeds and leave them in a bowl for garnish, for color and seasonings for food I prepare, because I want to eat them with my eyes, too. Also, I like very much to drink the delicious juice of the pomegranate."

The pomegranate is one of the seven fruits named in the Bible. Archaeologists have found images of pomegranates in the contexts of fertility and power. The Bible mentions them frequently, and, given the location of the Garden of Eden, the pomegranate was probably the "apple" that Eve ate and then offered to Adam. Throughout the Middle East and the Orient, the pomegranate was a sacred fruit. Solomon wooed the Queen of Sheba with his famous songs of budding pomegranates, and Romeo's nightingale sang of love to Juliet from a

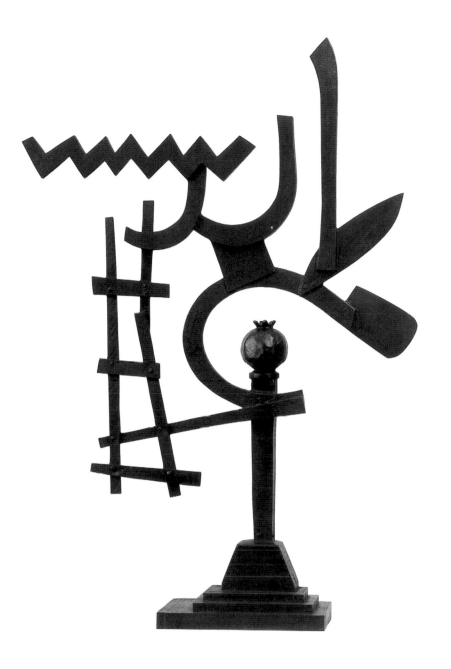

pomegranate tree. The ancients of Mesopotamia, where the fruit was looked up on as a love charm, often spoke of them.

The Assyrian sacred tree was the pomegranate, also known as the Tree of Life. The Arabs greatly prized the pomegranate and believed that whoever ate it had his heart filled with faith.

Images of pomegranates appeared in the ancient world, adorning buildings and paintings; pomegranates stood on the pillars of King Solomon's temple. The fruit has inspired the fabrics and paintings of many artists, particularly in the

Red Pomegranate 1983 Bronze Cast. H 48 ½" W 33" D 9 ½" (123 x 84 x 24 cm)
Sculpture No.160 (ED 3) Collection: Art Gallery of Hamilton, Hamilton, Ontario, Canada

Middle East and Africa. The Greeks, too, were fond of the image. Aphrodite, the goddess of love, is said to have planted pomegranate trees wherever she went. In Greece, as a symbolic gesture of fertility—from Hellenistic times until today—a pomegranate is broken on the ground at weddings, and on New Year, as a symbol of abundance, fertility, and good luck.

The word *pomegranate* comes from the Latin *Punica granatum,* "the apple of many seeds." Most sources say the fruit originated in Iran, Iraq, Israel, Syria, Egypt, or Afghanistan. The pomegranate was cultivated by kings; it was grown in the fabulous hanging gardens of Babylon. In Asia, it is "Chinese apple." In Spain it is "Granada," in the Arab world "Reman," in Hebrew "Rimon" in Hindi "Anar," and in Turkish "Nar." The Chinese call it "Shiliu," and the Greeks call it "Rodi."

It is said of Israel that she is full of good deeds as a pomegranate is full of seeds (Babylonian Talmud).

The Spanish brought pomegranates to the New World through Mexico, where the fruit gained popularity among many, including cooks, who have used pomegranate juice in their culinary creations for centuries.

The pomegranate is very good nutritionally. It is high in potassium and contains vitamin C. It also aids digestion. When you cook with pomegranates you will discover a wealth of delicious dishes.

The pomegranate is topped with flowers in a crown and looks like a jar or a bell. The pomegranate tree begins bearing fruit after three years. It must be pruned in order to have many side branches that hold the fruit. Most of the pomegranates grown in the United States come from California and usually last from September to December, after which they disappear for another year. They are very rare and special.

Oded Halahmy began using the pomegranate symbol as naturally as other artists might use circles or squares. Easily integrated into the artist's large and lyrical sculptures and art objects, which are light, open, and yet full of references to history, his pomegranates are used with unexpected whimsy. They might be placed precariously on top of sculptures or turned into candelabra. He explains this simply. "Pomegranates are perfect," Halahmy says. "They offer spiritual and physical well-being."

–Esther Cohen, New York City, Spring 1998

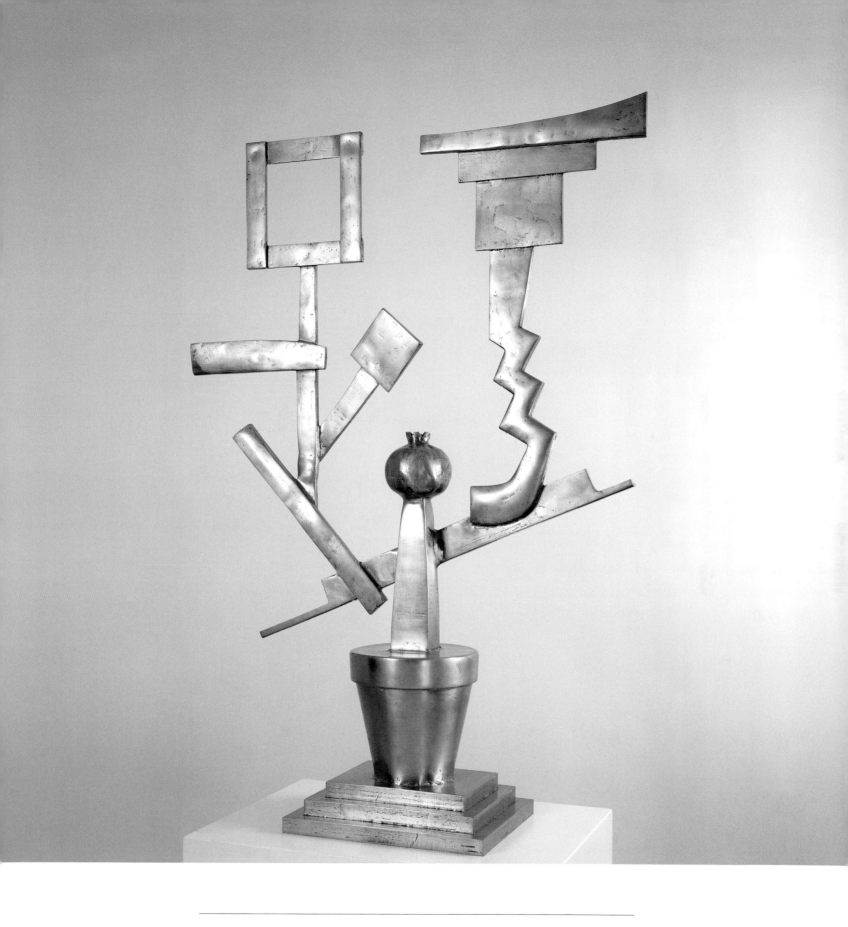

Spring Sky 1985 Nickel Bronze Cast. H 48" W 33" D 10 ¾" (122 x 84 x 27 cm)
Sculpture No.165 (ED 3) Private Collection: Los Angeles, California

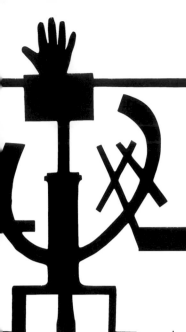

Meeting Oded Halahmy

It is the fate of artists who strive for universal meanings to be connected in the minds of others to the events of a particular time and place. In the eyes of the American and European art worlds, Oded Halahmy is surely a topical figure. I met him while he was visiting London in May 2003. The American and British invasion of his native Iraq had just been accomplished, and thousands of dead were also being counted in his second, contested homeland of Israel and the Palestinian Territories.

A distinguished sculptor who has lived and worked in New York's SoHo since the 1970s, Halahmy has not allowed the international success of his largely abstract work to distance him from the horrors of his formative lands. Art and geopolitics met early in his experience. His father, Salech Haskel Chebbazah, was a prosperous goldsmith in Baghdad. Atheist doctrines did not, however, prevent him and his family from celebrating the Jewish scriptural traditions. The abiding impression of Halahmy is of great personal warmth and enjoyment of life. He signs his notes and letters "With Love." As we breakfasted on Middle Eastern pastries in his brother's sunny London garden, he told me that Jews had made up more than a quarter of the population of Baghdad before the founding of the State of Israel. He and his family were airlifted there, along with 100,000 of their compatriots, in 1951. He was twelve years old at the time, and contrasts the halcyon memories of a liberal metropolitan childhood with the experience of being an immigrant, sprayed with DDT, strewn in trucks, and left to spend the winter in wind-ripped tents. His parents had to abandon their livelihood and their property in Baghdad. Reduced to menial work, they eventually managed to buy a small house in an Arab neighborhood of Jaffa, where they surreptitiously listened to Arabic music that was disapproved of by the Israeli authorities.

The young Oded was too busy completing his schooling and military service, helping to look after his brothers and sisters, and working as a gardener and a house painter

in the wealthy northern suburbs of Tel Aviv to afford formal artistic training, but his vocation was too strong not to take shape. By the late 1950s, he was teaching himself drawing, painting, and sculpting. He fell in love with wood, relishing the irreversible commitment of carving and its ancient traditions. Wood is still his medium of origination, before casting his designs in bronze or steel. In the walnut *Gazelle Relief* of 1961, his chisel-furrows expressed the tension of an animal poised to bound away. One of his first commissions was a monument, for the city of Bat Yam, to the Jewish refugees who converged illegally on what was then British Mandate Palestine. Measuring some four meters in length, *Daring* (1963) depicts in bold, folk-art style a boat in mahogany relief. Its passengers huddle behind the sail and strain their oars against a writhing sea. Halahmy was soon able to open a studio in Tel Aviv. He produced curvaceous, massive, and visibly crafted forms, exploring bronze, cement, and plaster as well as wood. Although varied in style and subject matter, many of his early works, from the Art Deco *Torso of Tamar* (1964) to the hint of Giacometti in *Naimah* (1964) and the abstraction of *Bird in Flight* (1965), display the aerial ambition and celebratory spirit that distinguish his later work.

Modernism was the international artistic language that enabled Halahmy to transcend political and cultural boundaries. "The gate swings open, you are gone," Halahmy's sister-in-law Miriam recounts, in a series of poems that she composed about his work. In 1966, he closed his studio and headed across Europe to drink from its braided streams of Orient and Occident. Among the Mesopotamian antiquities of the great museums, he found a home away from home. In Italy, he marveled at the masterpieces of Michelangelo. In Paris, he took in the first twentieth-century modernists, especially the primitivism of Matisse and Picasso. Crossing the Channel to Britain, he delighted in the spicy Indian cuisine that was then becoming popular. Its bright turmeric yellows and cochineal reds later inspired the coloring of some of his sculptures. In London, he settled for two years to pursue advanced studies at St. Martin's School of Art, which was then a cutting-edge center for sculpture under the direction of Anthony Caro, Philip King, and others.

In the ornate gilded spaces of London's Theatreland, Halahmy also began to develop his interest in dance. He considered Martha Graham's dancers to be moving sculptures, and later studied Merce Cunningham, David Smith, and the break-dancing movement of the 1980s. To meet him in his mid-sixties today is to be impressed by his sprightly, gymnastic physique. "I feel like an athlete, a performer, a dancer or conductor," he writes. "I am fit and in good physical shape. I move and dance with my work using rhythm and harmony, both fast

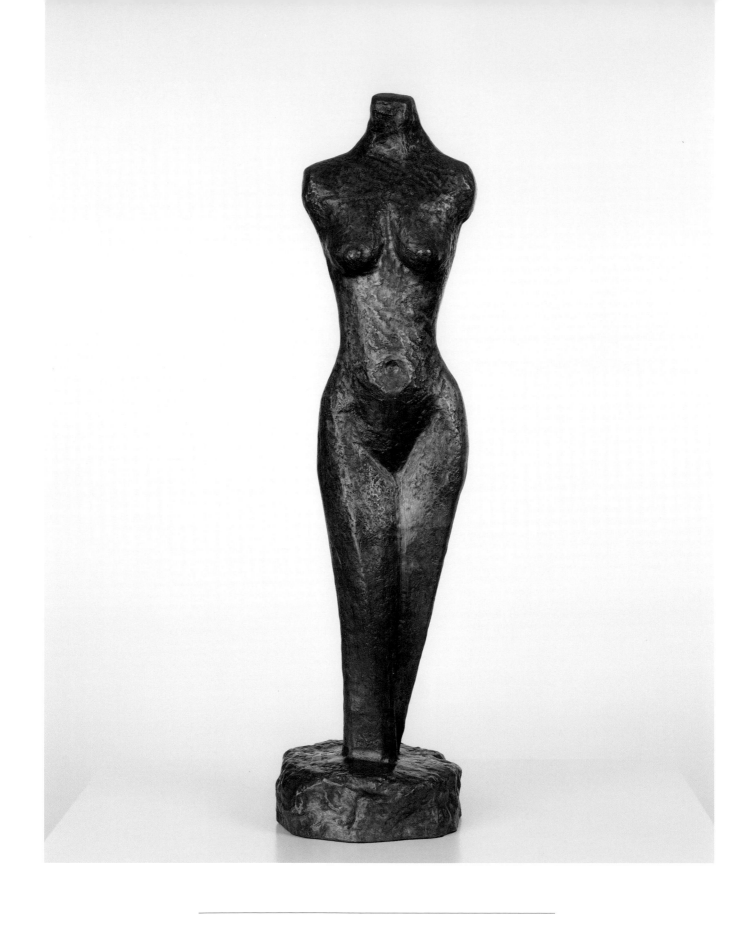

Figure (Tamar) 1964 Bronze Cast. H 26 ¾" W 7 ½" (68 x 19 cm)
Sculpture No.19 (ED 9) Private Collection: London, England.

and slow." Photos of Halahmy at work show him enthusiastically darting around his emerging sculptures, creating space by movement. Just as poetry is first and foremost about words, so Halahmy orchestrates physical forms rather than concepts. Critics would later describe his style as "lyrical abstraction." Its poetry accords more with Middle Eastern traditions of public, ad-libbed performance than it does with solipsistic European Romanticism.

Halahmy began to shed his tentative eclecticism and to strike out confidently with his own abstract but representational style. He cut deep angles in bronze as well as in new materials such as Plexiglas and Styrofoam, as in *The Couple No. 3* (1966). The influence of Caro, of course, remains clear in Halahmy's later work, but these years also show the influence of Henry Moore and his circle, including Ben Nicholson and Barbara Hepworth. There is an interest in apertures, held in tension with a tectonic dynamism. Moore indeed spotted Halahmy's talent and helped him to understand the techniques of enlargement and sculpting on a monumental scale, even offering him an assistantship. This Halahmy did not take, but, having learned how to teach in an expressive and experimental environment, he accepted a teaching post at the Ontario College of Art in Toronto.

It was a wise move, because here, with the help of a fabrication shop, Halahmy was able to originate his works in full size, often to be finished in stainless steel or bronze, and to move on to a new level of boldness and independence. He thrilled at working with the assistants and wielding the heavy industrial equipment, and he always insisted on taking manual charge of his work rather than farming it out. His sculptures assumed a fresh and spare elegance, quivering, as in *Earth and Sky* (1969-70), or describing geometric arcs and parallelograms, as in *Spring Is Here* (1970) and *Hold* (1969). Halahmy had a major one-man show at the Gallery Moos in Toronto, and one of his sculptures, *Forthright* (1968-69), was exhibited alone in Nathan Phillips Square. He had now created the fulcrum of a gleaming plate-glass plaza, a fully mature outdoor piece that could choreograph itself to the changing weathers, seasons, and passers by.

Halahmy's final destination was to the United States, in California. He was immediately intoxicated with the sense of space, freedom, and artistic possibility that he found in this country. He took his Ontario students to SoHo to see the critic Clement Greenberg's established world of Abstract Expressionism as it stood on the cusp of a new generation of pop artists such as Roy Lichtenstein and Andy Warhol. Between these two movements, he nevertheless found tolerant contrast rather than fashion,

partisanship, or dogmatism. There was also plenty of experiment action in video, performance, and graffiti art, which chimed in perfectly with some of the teaching methods he had been innovating in Toronto. "Everyone started painting their culture," Halahmy remarks, "It was a young culture." By 1971, he was able to move to a SoHo loft and take up teaching and creating at the Cooper Union School of Art and at the Parsons School of Design. He had to leave most of his large sculptures behind in Canada. "Only then," Halahmy says, "did I feel as free as a bird."

Nearly penniless, but free from ethnic discrimination, academic pecking orders, and the atavistic histories of the Old World, Halahmy turned his loft into a utopia. He worked on large sculptures, limited only by the vast floor space ("like a landscape... over 4,000 square feet with a nine-foot ceiling and a spacious freight elevator") and such materials as he could find in dumpsters. "I did not know what I would do with these large sculptures," he said. "I just had fun making them. I was playing with materials, moving and dancing with forms, like a child. What a joy! In a way, space produced art. Out of nothingness, creativity emerged. People came. My loft was a mecca for friends who often stayed over. It was all happening in my loft: making art, making love, sharing everything I had. My friends became my family: a little like a kibbutz."

Through dialogue with his self, his body, and others, Halahmy began to reach what an art critic Eleanor Heartney has called his "fourth and most persuasive homeland the realm of the imagination." From the freedom to move, as well as to stay, came peace. Activity was his quietness.

However abstract they became, and however prestigious the sites they graced, from San Francisco to the leafiest New England estates, Halahmy's cavorting monuments of the 70's never abandoned their Middle Eastern roots (*Arabesque*, 1974; *Nimrod*, 1973; *Sukkah*, 1975-79). In 1980's, in the afterglow of the Israel-Egypt peace treaty, he visited Egypt for the first time. He underwent a creative crisis as he toured the antiquities, talked with art students, listened to music, went to nightclubs, and wished he could spend all night in the Egyptian Museum in Cairo. "How could I digest all these ancient works of art?," he says, "I was stunned by the power and spirit and by the freshness of the color. I was talking to myself and saying, 'Should I hide among the statues? Maybe the guard wouldn't see me." His eventual solution was to travel back toward the figurative, but reaching deeply into personal memory and the universal elements of the Middle Eastern heritage. He began to play with the common symbols of the diverse cultures that sprang from the cradle of civilization—the pomegranate

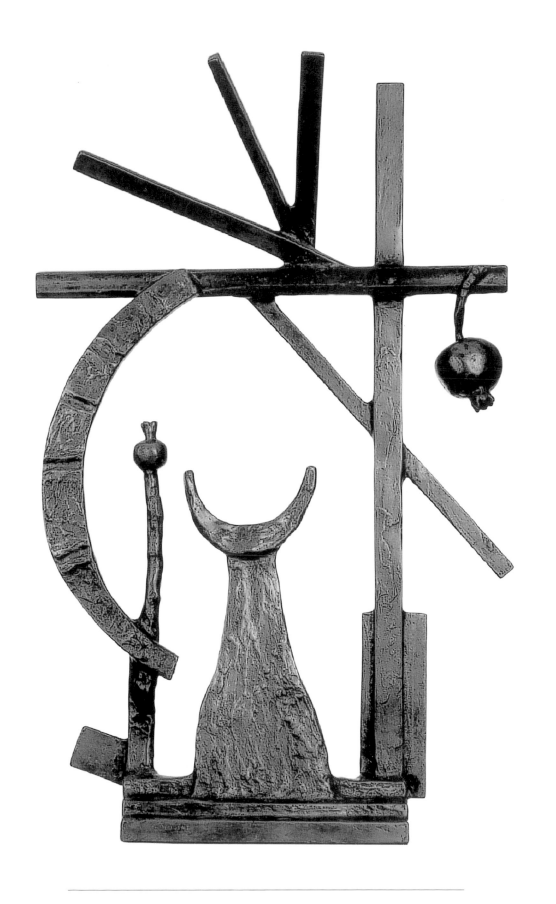

Sky Moon Pom 1997 Bronze Cast. H 35" W 23" D 8" (89 x 58 x 20 cm)
Sculpture No.234 (ED 5)

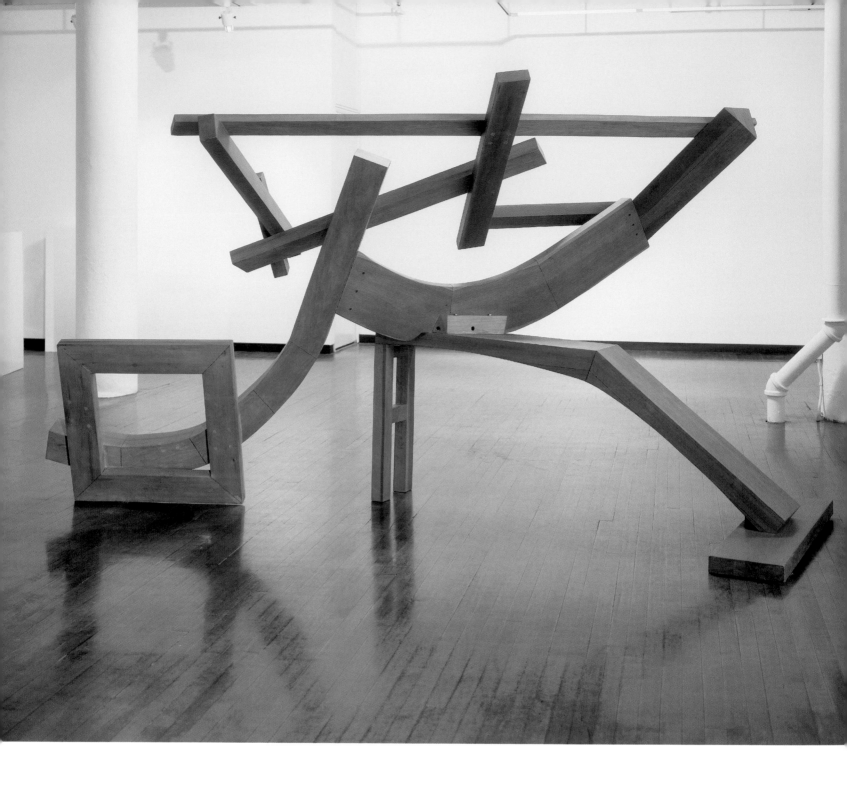

Arabesque–Homage to Gandy Brodie 1974 Poplar Wood. H 81" W 156" D 101" (2.06 x 2.96 x 2.31 m)

Sculpture No.87 (Unique)

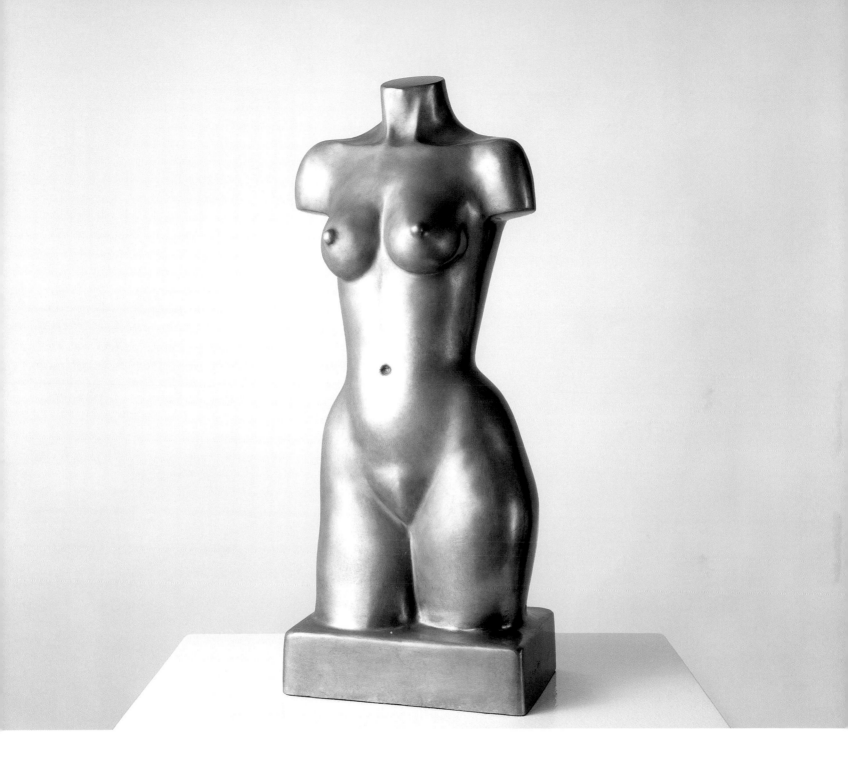

Torso of Tamar 1964 Bronze Cast. H 22 ½" x W 8 ½" x D 6 ½" (57 x 21.5 x 16.5 cm)
Sculpture No.19B (ED 9)

of love and fertility, the amulet hand of sanctity, or the palm tree that links earth, water, and sky. Halahmy incorporated these images into zigzag, mirage like tableaux inspired by the graphic exuberance of ancient Mesopotamian art. Works such as *Babylonian River Banks* (1989) and *Sky Moon Pom* (1997) resemble fantastic, teetering, humanoid contraptions unearthed by a bewildered archaeologist, the remnants of some fanciful lost technology.

Since his *Voice of Peace*, completed on March 26, 1979, six days after the historic handshake of Anwar Sadat, Menachem Begin, and Jimmy Carter, Halahmy has been exploring the themes of harmony and tranquillity in his work. He has been indomitably positive throughout the years of Iraqi dictatorship and other obstacles in the Middle East. His celebrations of liberty, mobility, openness, and the hybridization of East and West stand in obvious contrast to the conceptual protests of the Palestinian-British artist Mona Hatoum, whose pieces, such as *No Way III* (1996) and *Set in Stone* (2002), express the pain and violation of confinement. Nevertheless, Halahmy has a realistic side that extends beyond the studio, based partly on his military experience. He has established a foundation to support artistic expressions of peace and hope throughout the world, and especially in the Middle East. It currently funds the translation of Hebrew and Arabic writers, including Israelis and Palestinians, into English. On the morning that I met them, he and Miriam were still buzzing from the launch the previous evening of *Iraqi Poetry Today,* a major collection edited by Daniel Weissbort and Saadi Simawe, whose publication his foundation had supported. The emotional charge of the moment had kept the readings going until the small hours. It would be an orientalist conceit for me to elect representative poets or quotations from this polyglot, multiethnic nation-of-the-imagination-in-exile. But its verses will not comfort those who envisage a country that is compliant to Western capital and military might.

After fish-and-chips for lunch in a nearby café, we part at the British Museum. I leave Oded and Miriam amid the unrivaled collection of Assyrian antiquities, the looting of whose cousins in Baghdad is the subject of propaganda and counter-propaganda in the news. Many of the reliefs are gory, depicting warfare and hunting, but they also include signs of a bountiful land: cereals, palm trees, and pomegranates. One, from Tiglath Pileser (745-727 BCE), shows a city under attack from a siege engine that bears a striking resemblance to a modern Abrams tank.

–Marius Kwint

Endnotes

Ali, Tariq. "Resistance Is the First Step Towards Iraqi Independence." *Guardian* (London), 3 November 2003.

Archer, Michael, and Greg Hilty. *Material Culture: The Object in British Art of the 1980s and 90s*. London: Hayward Gallery, 1997.

Crawford, Vaughn Emerson et al. *Guide to the Collections: Ancient Near Eastern Art*. New York: Metropolitan Museum of Art, 1966.

Halahmy, Miriam. *Cutting Pomegranates*. London: David Paul, 2003.

Halahmy, Oded. *Oded Halahmy in Retrospect: Sculpture from 1962 to 1997*. New York: Oded Halahmy and Louis K. Meisel Gallery, 1997.

Halahmy, Oded. *Homelands: Baghdad, Jerusalem, New York. A Retrospective: Sculpture of Oded Halahmy*. New York: Yeshiva University Museum, 2003.

Kuspit, Donald, and Sundaram Tagore. *The Common Ground: The Sculpture of Oded Halahmy*. New York: Sundaram Tagore Gallery, 2002.

Reade, Julian. *Mesopotamia*. London: British Museum Press, 1991.

Winter, Irene. "Defining 'Aesthetics' for Non-Western Studies: The Case of Ancient Mesopotamia." In Michael Ann Holly and Keith Moxey, eds. *Art History, Aesthetics, Visual Studies*. Williamstown, Mass. Sterling and Francine Clark Art Institute (distributed by Yale UP, New Haven and London), 2002.

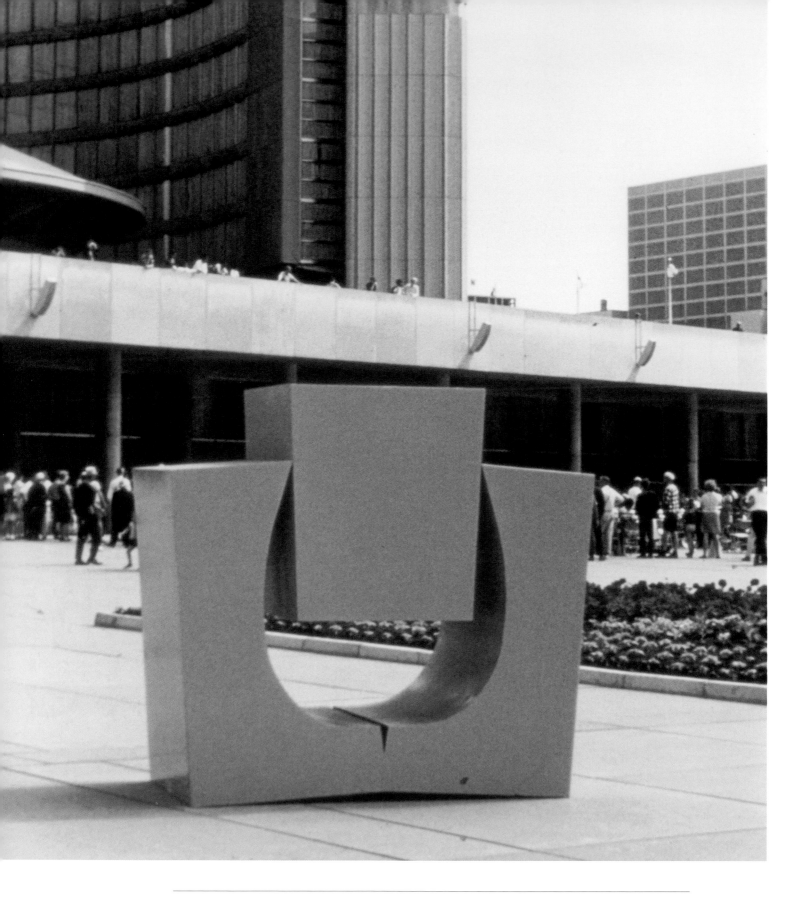

Forthright 1968–69 Wood and Plywood Painted Yellow. H 80" W 88" D 42 ½" (2.03 x 2.23 x 1.08 m)
Sculpture No.60 (Unique) Exhibited at Nathan Phillips Square, Toronto, Ontario, Canada
Private Collection: Toronto, Ontario, Canada

Oded Halahmy's
Sculpture Defies Easy Categorization

Halahmy has worked for many years in bronze, a noble material fraught with antique associations. However, unlike his classical predecessors, Halahmy mainly uses wood—instead of wax or clay—to form the model from which his bronzes are cast. Wood cannot be modeled. It is cut, carved, or pieced together, techniques that we do not generally associate with the production of bronzes.

Halahmy assembles his sculpture. The roots of this practice go back to Picasso's Cubist still lifes of 1912-13, at least as far as the Western modernist canon is concerned. Many artists followed the Spanish master's lead and thereby helped to develop one of the fundamental techniques of twentieth-century sculptural production. This method allows for the accumulation of the kind of inexpensive materials that were traditionally sidelined by sculpture. Significantly, Halahmy transforms the cheap, ephemeral-looking substances used in his assemblages into something more precious and seemingly everlasting. He was, after all, born in the heart of ancient Mesopotamia, and has a keen awareness of history.

Constructed sculpture has the ability to assume a range of configurations and incorporate a variety of images, textures, and colors that can be achieved only with difficulty, if at all, in carved or modeled sculpture. Carved and modeled sculpture is usually volumetric and closed. Assembled sculpture, however, can easily move away from mass and explore the play of lines and planes in actual space. Although Halahmy favored faceted volumes in his earlier works, he now uses mostly flat sections of wood and slates to shape his compositions. In his recent work in particular, there is no question about the materials and techniques that were used to shape the models from which the bronzes were cast. The original wood parts remain perfectly recognizable, despite the fact that their surfaces may be disguised by rich factures achieved by the superimposition of

the other materials. The processes that were used to piece the models together is also in evidence in the furnished works—in fact, they are integral to the look of Halahmy's sculpture.

Halahmy's work, though abstract and geometric in nature, resonates with life. This had a lot to do with the way his sculpture is formed—namely, with the art of assemblage, which can be an extremely playful mode of building up a composition. It is a method that invites chance occurrences. Carving, by contrast, is a laborious task that requires deep and ongoing concentration. You do not want any surprises when carving, for once accidents happen, they become extremely difficult or even impossible to correct. Modeling allows for error, as one can easily add or subtract wax, clay, or plaster from the composition one is building. However, rendering form through modeling requires intense deliberation. Not the art of assemblage, which is all fun and games compared with the aforementioned methods of sculptural production. To begin with, it does not necessitate to the skills of being able to model or carve, which were formerly considered essential for anyone wishing to produce sculpture. Assemblage did away with these prerequisites. The art of assemblage is, like collage open to all. This does not mean that anyone who can carve guarantee successful artistic outcomes in, say, clay or marble. Assemblage does allow for easy correction—far easier, in fact, than does modeling. This method of composition therefore encourages that artist to take risks that he or she might otherwise avoid, or at least ponder, when working in clay or marble. It therefore comes as little surprise to learn that Halahmy does not produce preparatory studies for his models but composes his work intuitively and on the spur of the moment. The art of assemblage makes immediate expression possible. In that respect, it is comparable to the experiments in *ecriture automatique* first conducted by Breton and Soupault, as well as to the various forms of "action painting" that developed in the wake of this revolution of literary expression. No wonder the art of assemblage—a method of creation rich with implications of freedom—was so cherished by the Dadaists and the Surrealists.

Oded Halahmy often listens to music and dances as he builds up his sculpture. It is the joy in creating his art which transpires from his work, which can at times be exuberant—a sentiment that most modern and contemporary sculpture eschews. Considering the artist's working methods, it is not surprising that recognizable, ready-made objects such as a ladle, a flower pot, and a pomegranate were eventually introduced into his geometric configurations. Their curvilinear shapes contrast with the hard, angular, largely flat geometric forms with which they are forced to coexist. Other figurative forms, like the palm tree or the flower motif,

are shaped by the artist and incorporated into his geometric compositions. Put together in a compelling way, these forms can conjure impressions of landscape, architecture, the city, industry, the human figure or still life, or remain comfortably ensconced within the world of abstraction.

Halahmy's motifs have symbolic value. The ladle speaks of nourishment, the pot of potential growth, and the pomegranates are, in the words of the artist, "an ancient and universal symbol of love, fertility, prosperity, and hope." He goes on to say, "Their seeds, rich and abundant, promise generous futures. Pomegranates are perfect. They offer spiritual and physical well-being." Halahmy's language is the language of hope; his ode is an ode to joy. His optimism is surprising in the light of what his family went through. Halahmy was born in Baghdad, the son of a successful goldsmith. His family was forced to leave Iraq in 1951—when Oded was thirteen years old—simply because they were Jewish, and they lost all of their possessions because they decided to immigrate to the newly founded State of Isreal instead of moving elsewhere. Only a certain type of individual can wholeheartedly embrace life following experiences of this nature.

Halahmy, who loves New York City, where he settled in 1971, remains deeply attached to the land, people, and culture of the region that is his homeland. The palm tree and the pomegranate motifs speak of his love and longing for his place of origin. In his work, Halahmy achieves a symbiosis between traditions that many of us today regard as distinct and even antithetical, although they have been in close and intimate contact at various periods in history.

While the art of assemblage is a branch of Western modernist sculpture, some of the imagery that Halahmy employs is Middle Eastern in origin. The very use of bronze—which is undoubtedly inspired in part by his father's use of gold to create objects of beauty—takes us back to the ancient civilizations of the Fertile Crescent and the Mediterranean. Materials have symbolic value. In addition, bronze has a warmth all its own. It is poured as hot liquid into a container and displayed, after cleaning, in its solidified state. Thus it becomes a perfect metaphor for artistic creation. Significantly, Halahmy and his collaborators cover his bronzes with acids and achieve an entirely new range of patinas. Halahmy is not shy of color. Neither was antiquity.

Oded Halahmy reveres ancient works of art. In 1966-68, while studying under

Phillip King and Anthony Caro at the St Martin's School for Art in London, he made frequent trips to the British Museum to lose himself in its outstanding collection of Middle Eastern antiquities. The Metropolitan Muscum of Art in New York, with its remarkable groupings of objects form the ancient Near East, is likewise a second home for him. The trip he made to Egypt in 1980 was, nevertheless, nothing short of an epiphany. "I was stunned by the power and spirit and by the freshness in color of these ancient works of art," he says. Back in New York, having spent long nights in nightclubs admiring belly dancers and absorbing large quantities of music in Cairo he felt emotionally drained. "I was in shock," he says. Following a long pause, during which he entertained friends at his home with cooking, he went back to work and began with greater urgency to incorporate natural forms into his sculpture, in an attempt to fuse his life with his art. His work became avowedly more playful.

Halahmy's preceding work could indeed be comparatively severe in appearance. Caro had warned him against using bronze, as the English sculptor considered this material to be outmoded and perhaps a little too bourgeois. Bronze is about the hand. New sculpture for our mechanical age should, instead, have a machine-made look. Bronze is about feeling and, to a considerable extent, good taste. Instead, something more distant, cerebral and, therefore supposedly elevated was required. These notions gained currency both in Europe and in the United States. We have seen how Halahmy embraces some of these ideas by moving away from modeling and often casting his bronze from hard geometric wood forms. A certain formalist rigor was deemed necessary. A large number of Halahmy's sculptures of the 70s, in particular, inscribe themselves within this line of thinking. Works like *Sight*, (1973) and *Odyssey* (1974-88) combine pure, geometric forms with immaculate surfaces.

Sight is an open construction of welded aluminum, painted in bright yellow. Two powerful diagonals that were connected at the top by an arch rise to the left of the juncture of a floor-bound horizontal and vertical. *Sight* is all about significant form. The openness of this construction and its suggestion of movement will be constants in Halahmy's work. In *First Peace*, a large bronze from 1976, for example, thin rectangular strips fan out from behind a broken resembling a distorted lectern, as a smaller lectern recedes dramatically toward the left. This ensemble works best when viewed from the front, like antique sculpture, much of which was made to be backed by architecture. The primacy of the frontal view is also a near-constant in the evolution of Halahmy's maturity.

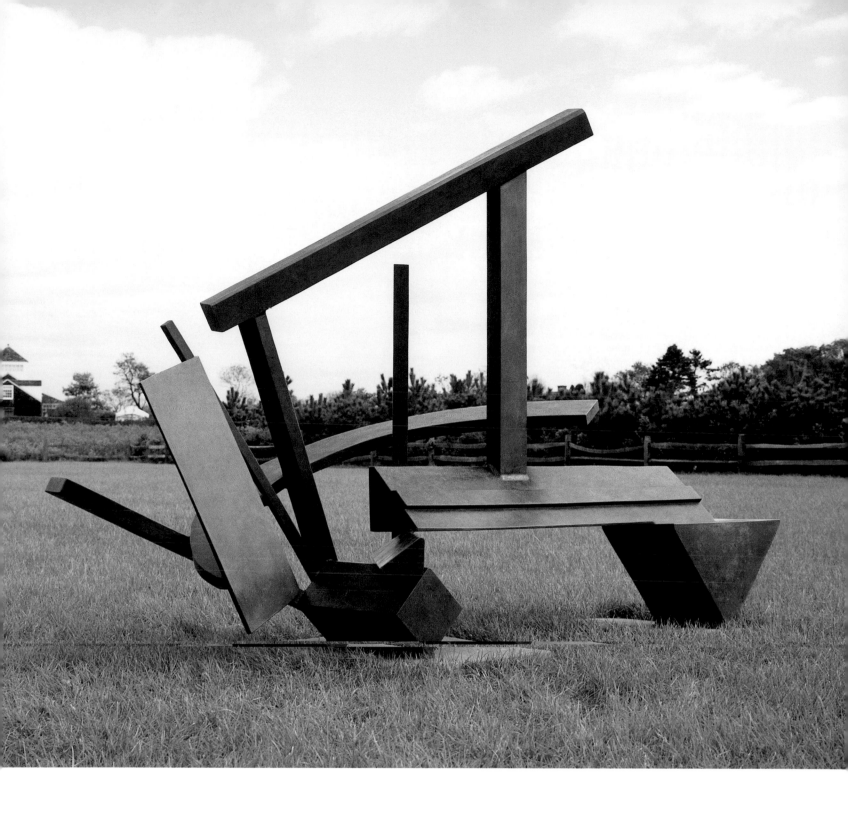

Odyssey 1974–88 Cast and Welded Bronze. H 78" W 115" D 62" (180 x 290 x 157 cm)
Sculpture No.88 (ED 3) Collection: Louis K. & Susan Pear Meisel, Sagaponack, New York

Round forms invite one to walk around the sculpture—oftentimes to the detriment of the piece, given that so much sculpture works best when seen from a limited number of vantage points. The flat or faceted forms used by Halahmy are less conducive to kinetic viewing. In fact, he almost always arranges his— often interconnected—shapes next to and/or above each other, so that we read them as we would forms in a relief. However, I should note that Halahmy does not produce relief sculpture; his work is always freestanding. His forms are arranged either parallel or at an angle to the imaginary front plane.

The paradigm of the relief sculpture does not work as well for the monumental *Arabesque (Homage to Gandy Brodie)* (1974), a work that contains both real and illusionistic depth all articulated by means of precipitously receding diagonals. However, this abstract construction—which stretches across space like an athlete or some great animal—works best when viewed from the front and from discrete three quarter angles, because other vantage points decrease the speed of the diagonals at the top of the composition. Much of this work's physical power derives from its weight and scale, something to which Halahmy is particularly sensitive, and which he undoubtedly appreciates in ancient works of art.

Halahmy's work that follows his discovery of Egypt often strikes me as having the quirkiness we relish in the sculpture of Ernst and Miró. Like those artists Halahmy is interested in the migration of signs into symbols. His sculpture has a hieroglyphic quality. Notwithstanding its seeming potential, it has an iconicity that is reminiscent of votive statuettes from Sumer. His stark, pared-down forms are expressive in ways that defy rationalization.

Take that bright-green bronze study for *Homeland* (1987), with its zany, broken rhythm. The five forms rising side by side along firm vertical axes cheerfully defy the laws of gravity, despite the fact that their trunks are broken in as many as three parts, and the fragments are made to partly overlap and thus to exist in different spatial planes, however discrete. With the exception of the pomegranate and the thin curved platform toward the rear of the base, all the forms are flat. The massive, closed pomegranate is played off against an open square that may be read as a head, as the shaft beneath the square supports diagonals on either side that function as arms raised up in joy. A palm tree with its trunk curving at the center towers over the composition. Architecture and a rising sun are arranged farther to the left. This work reminds us of how important the outlines of forms are to this artist's conception of sculpture. The sharply delineated geometric shapes slice through the air as they reach upward.

Homeland also offers testimony to the ongoing importance of color in Halahmy's sculpture. Each of his work receives only one color, which always fulfills an abstracting function. The artist has observed that his palette is informed by the hues of exotic fruits.

In more recent works, Halahmy has sought to attain a richer, increasingly painterly fracture. We find a degree of spontaneity and seeming innocence in his sculptures that are reminiscence of the art of children, as well as of the work of artists who were inspired by children's art. In the dark-brown bronze *I Stand for Flowers* (1996), a figure holding a flower in one raised hand is built up of what appear to have been the merest scraps of wood. This artist has long enjoyed using found or leftover—and thus ready-made—pieces of wood to build up his compositions. When we look at his sculpture we realize how important context is to the meaning of a work of art—something Picasso and Braque demonstrated in their Analytic Cubist paintings so rich in signs. Two diagonals rising at the opposite angled from a horizontal rectangle raised on top of two short vertical signify arms attached to a torso that is supported by legs. Once again Halahmy's interest in antiquity comes to mind. It is as if he were rediscovering how images were first made. A broken vertical supporting a diagonal bearing four more verticals rises from the center of the rectangle the thus becomes one of the strangest imaginable signs of the head. The stripes may stand for ideas that are inside the head, for relation to the rest of the body. Such a reading of the stripes is seemingly corroborated by *City in Bloom* (1997), a dark-green bronze rich with tonal contrasts, which inscribes itself within the best tradition of Dadaist and Surrealist assemblage. In this sculpture, the hollow and round end of an upright ladle stands in for the head, crowned by a horizontal supporting three vertical slats, a palm-tree and a pomegranate. The latter configuration suggests ideas and dreams of the homeland, where the palm tree grows. Halahmy's longing is expressed by means of joyful evocations, and not through suffering. It is given form through what appear to be chance combinations and free associations, which give his works the aura of dreams.

–Michaël J. Amy

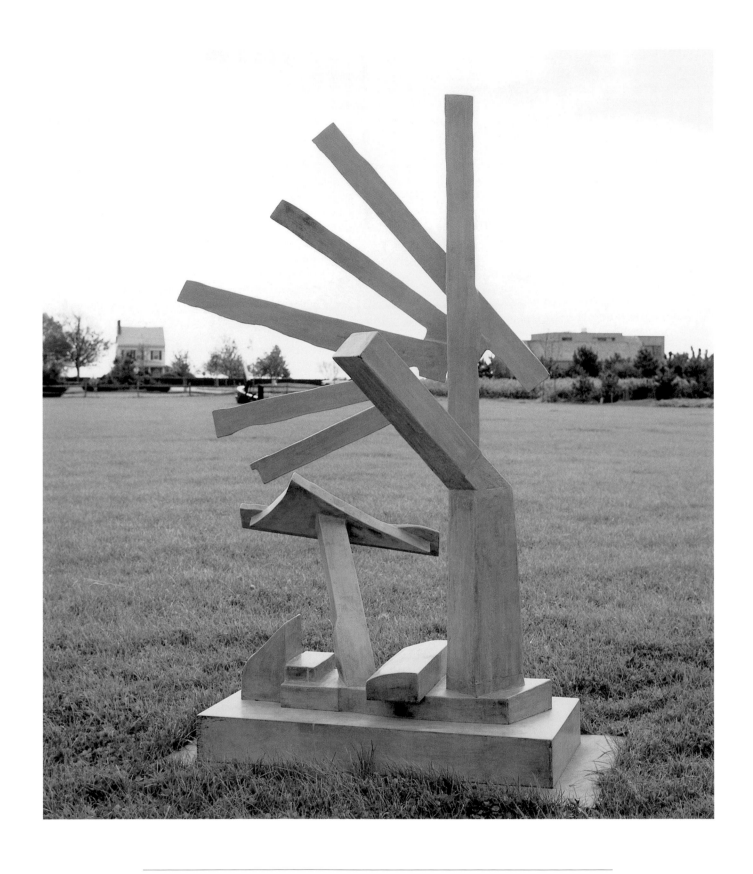

First Peace 1976 Bronze Cast. H 90" W 58" D 56" (229 x 147 x 142 cm)
Sculpture No.96 (ED 3) Collection: Louis K. & Susan Pear Meisel, Sagaponack, New York

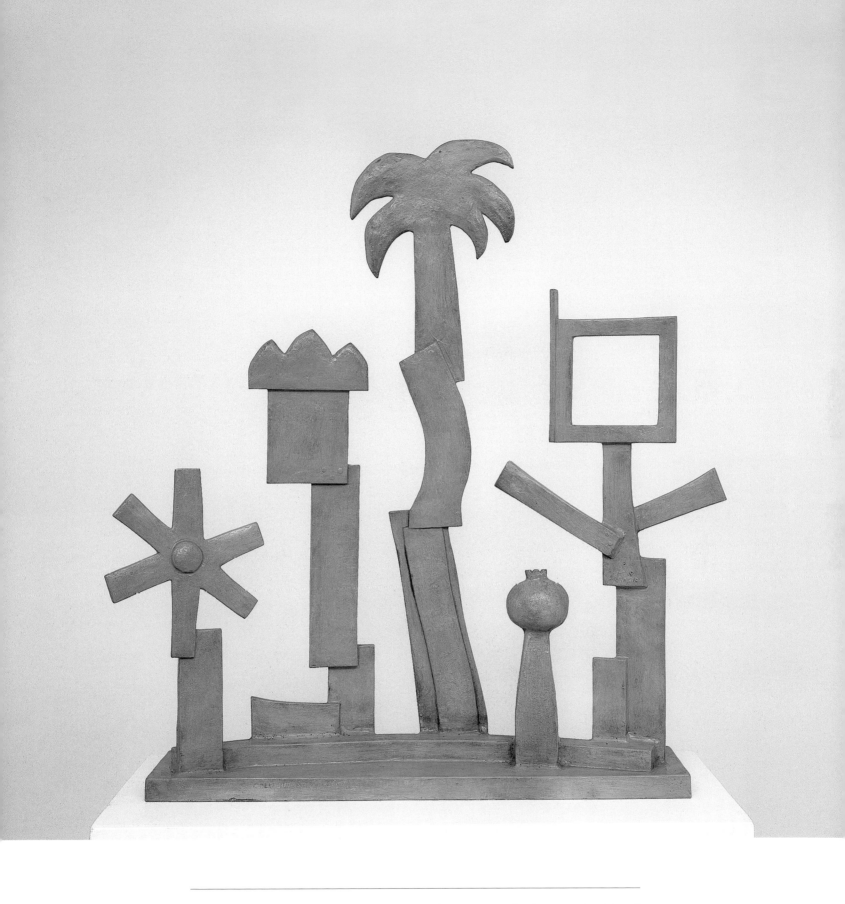

Homeland (study) 1987 Bronze Cast. H 47 ½" W 44" D 8 ½" (120 x 112 x 22 cm)
Sculpture No.175 (s) (ED 5) Collection: Linden Nelson

Oded Halahmy's Modernist Sculpture

Sculpture is the art of using three-dimensional space, and there are two fundamentally different kinds of space, and therefore two fundamentally different kinds of sculpture, Wilhelm Worringer argues in his influential book *Abstraction and Empathy* (1997). On the one hand, there is abstract sculpture, "inorganic-crystalline" in appearance, and thus conveying a sense of eternal space, as Worringer says, for all signs of contingency, relativity, and temporality have been banished from the sculptural object, or sharply reduced. Cycladic sculpture is the example he offers: the human figure has been geometrically "clarified," giving it the timeless aura of pure form. On the other hand, there is "rounded" representational sculpture, involving an empathic feeling for "organic structure" and evoking "organically beautiful vitality" and natural space. Here Michelangelo's figures are his example: they seem more inwardly alive than life itself—more organic than any existing organism. Worringer thinks that in modernity the gulf between the two kinds of sculpture has become greater than it has ever been. He believes that the task of sculpture is no longer to push to one extreme or the other but to aesthetically integrate the two poles—to make sculpture that is at once abstract and empathic, reconciling pure and organic form in a dialectical structure.

Oded Halahmy creates such sculpture: the magnificent *Mirage* (1976) is a major example. The work is a tour de force of formalist virtuosity and complexity: highly individual shapes, some organically evocative, others conspicuously geometric, extend in a continuum that resembles a frieze, as though a mystery play of pure forms were being performed. The forms are more or less flat, but taken together, and intricately aligned, they project forcefully. *New Mirage* (1986) works the same way, in a more concentrated format. The work is severe and minimalist, but a form suggestive of a growth capriciously

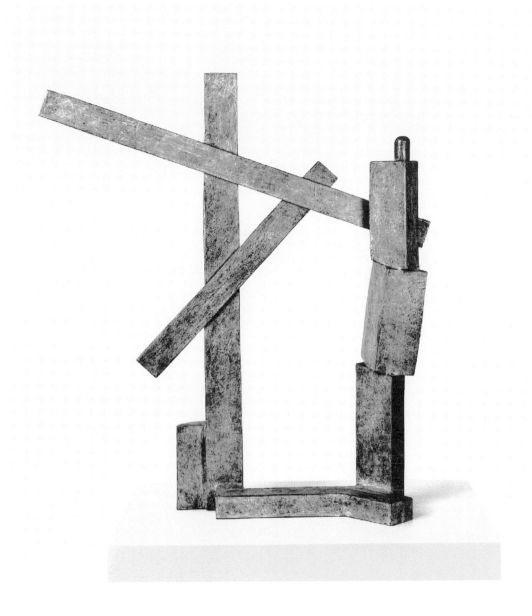

crowns it. Ingeniously playing flatness off against projection—balancing them in a subtle tension—is a leitmotif of Halahmy's sculpture. It is elegantly visible in *Metropolis* (1979) and *A Place* (1980). Their portal-like character reminds us of the traditional likeness of architecture and sculpture. Each implies the other, and sometimes architecture has a sculptural look, and sculpture an architectural look, as several of Halahmy's sculptures illustrate. Their scale in fact seems to demand an architectural context, as a foil to set off their grandeur. Halahmy's works can be regarded as a kind of sculptural construction, tending to

Metropolis 1979 Bronze Cast. H 32" W 30" D 6" (81 x 76 x 15 cm)
Sculpture No.125 (ED 5) Collection: Louis K. & Susan Pear Meisel

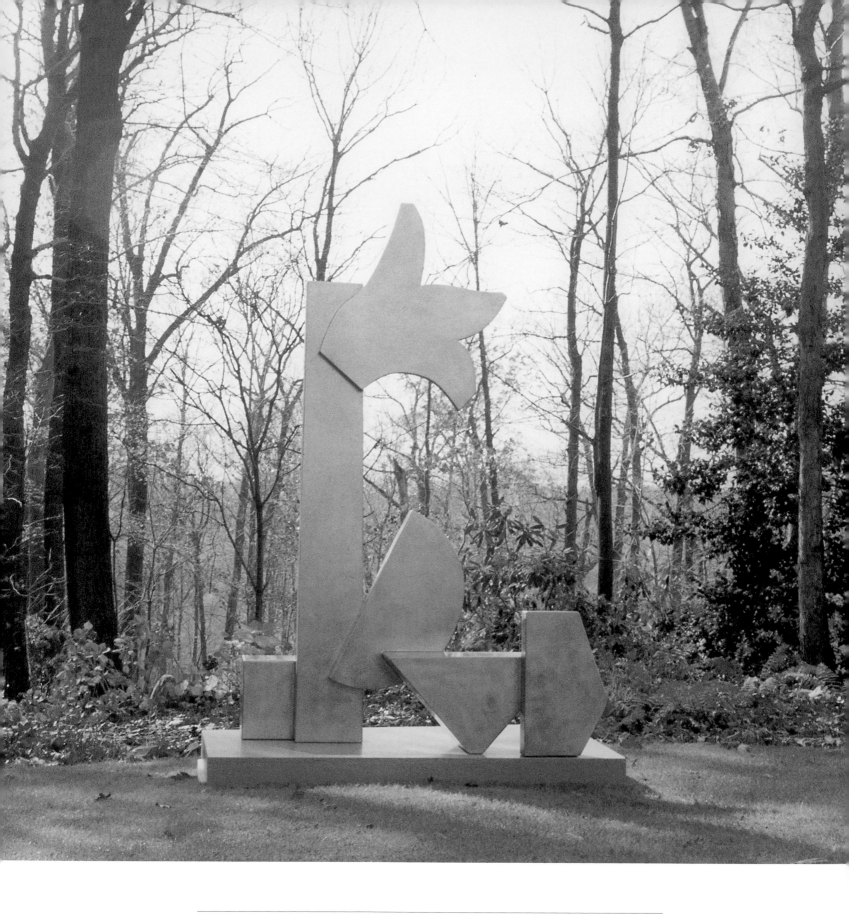

New Mirage 1986 Welded Nickel Bronze. H 97" W 61" D 33" (2.46 x 1.55 x 0.84 m)
Sculpture No.102 (Unique) Private Collection: Mill Neck, New York

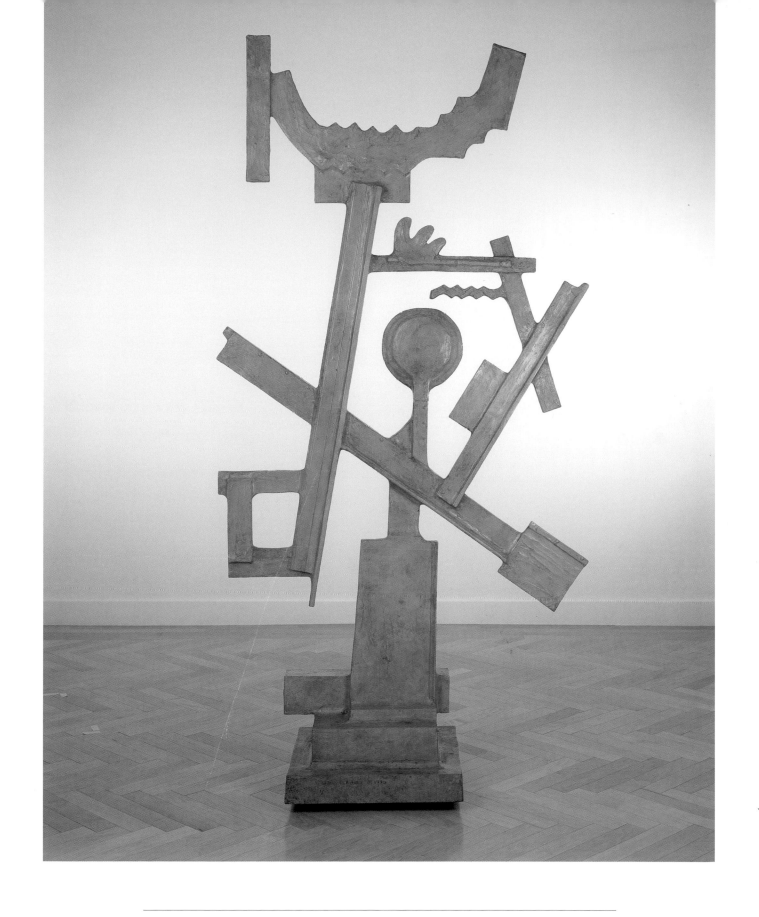

Mesopotamian Dance 1990 Bronze Cast. H 96" W 50" D 19 ¾" (224 x 227 x 50 cm)
Sculpture No.191 (ED 3)

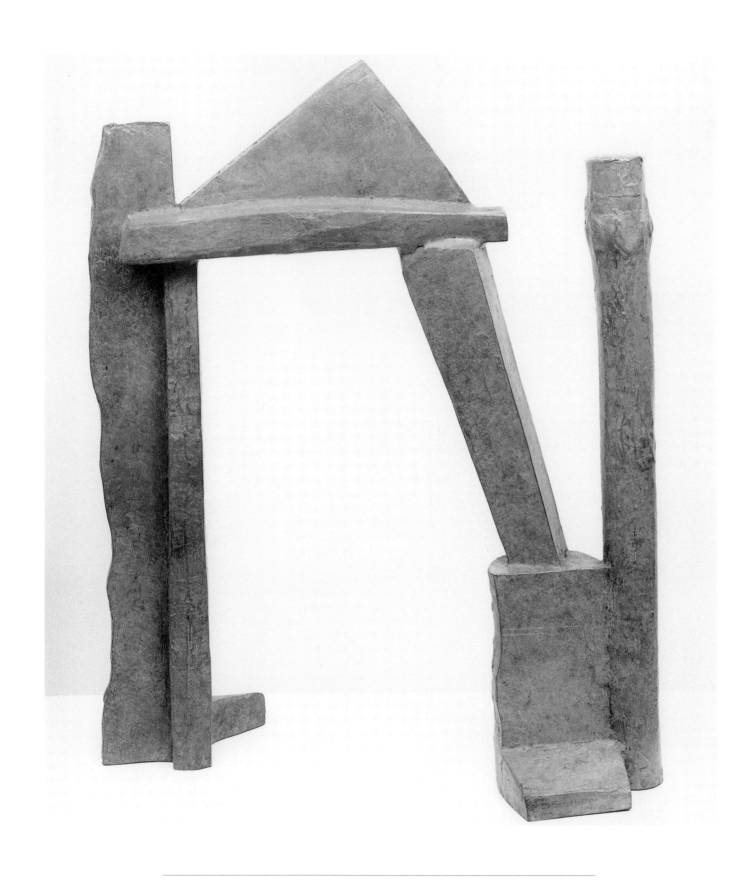

A Place 1980 Bronze Cast. H 27 ½" W 22" D 10" (70 x 56 x 25 cm)
Sculpture No.129 (ED 9) Collection: Ted Lebowitz, Edith S. Peiser, Talma Gallery

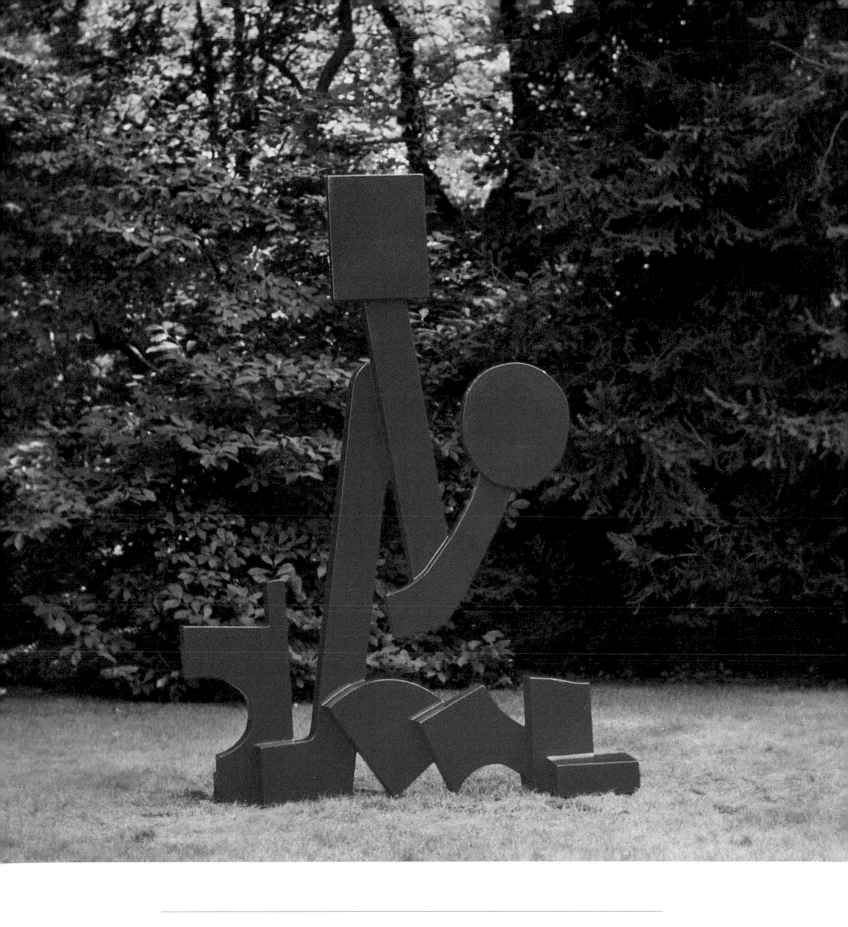

Up to Me 1979–81 Welded Aluminum, Painted Red. H 94" W 71" D 30" (239 x 180 x 76 cm)
Sculpture No.119 (Unique) Collection: Susan and Peter Schweitzer, Scarsdale, New York

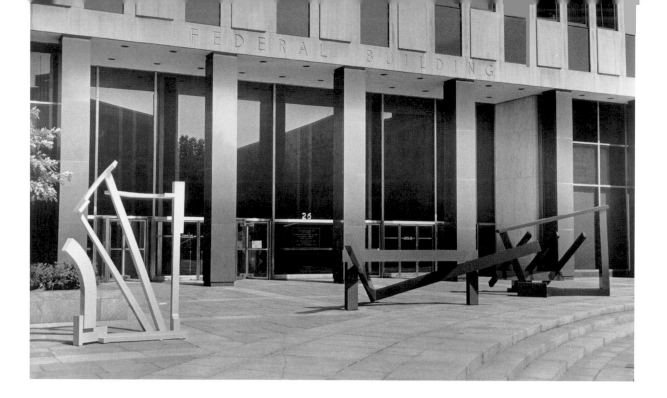

As part of the bicentennial celebration, the federal government has been fortunate enough to include the works of Oded Halahmy, a prominent international sculptor. Halahmy, whose works will be filling Federal Plaza in lower Manhattan, has had many shows in America and abroad, both individually and with other famed sculptors, such as Joan Miró, Alberto Giacometti, Henry Moore, and Louise Nevelson.

Halahmy's monumental tribute to the rich and colorful life that he so powerfully sees and translates into steel will be part of the U.S. General Services Administration's very exciting program of bringing art to the streets, accessible to lunchers, walkers, and wanderers. His pieces are open to the sky and the grass and everyone around.

He uses color as part of his surprise, as a unity, forcefulness, as a symbol for what we do and already know before we encounter his interpretations of blues brighter than seas, sun yellows, desert reds, earth browns. Halahmy's colors are New York City, Baghdad, Jerusalem, and all the world.

His interplay of forms, as well as his elegant, classical movements, add a welcome, strong, and wonderful note to this city's festivities.

For this we are grateful to the CAPS (Creative Artists Public Service) program, which had the foresight to enable us to enjoy Halahmy's work, and to Halahmy himself, who lent the pieces to the Federal Government Building from the summer of 1975 to 1976.

Esther Cohen, Executive Director, Bread and Roses 1199 / SEIU

From left to right: **Sight, Talisman, Nimrod** on exhibit, Federal Plaza Building, New York City

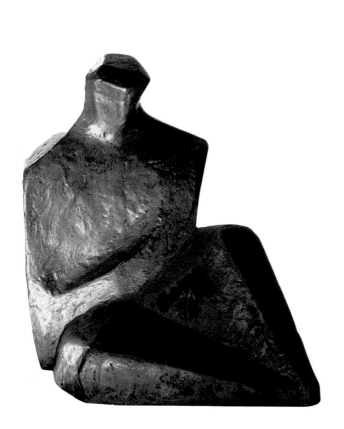

Left: **Seated Figure (Tehina with Silan)** 1963 Bronze Cast. H 14 ¾" W 15 ½" D 9 ¼" (37 x 39 x 23.5 cm)
Sculpture No.8 (ED 9)

Right: **Young and Round** 1964 Bronze Cast. H 5 ¼" W 10 ½" D 8 ½" (13 x 25 x 21.5 cm)
Sculpture No.15 (ED 9)

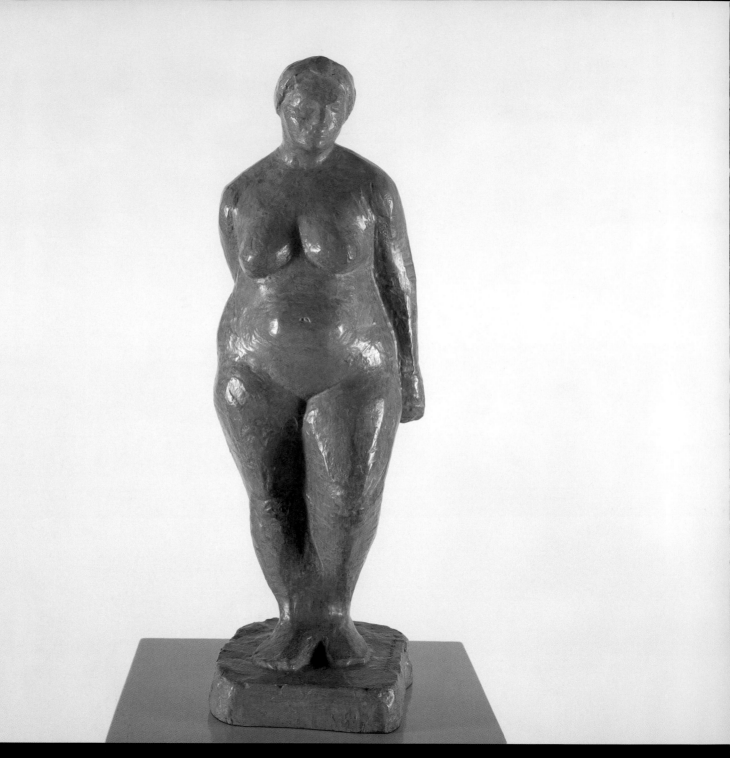

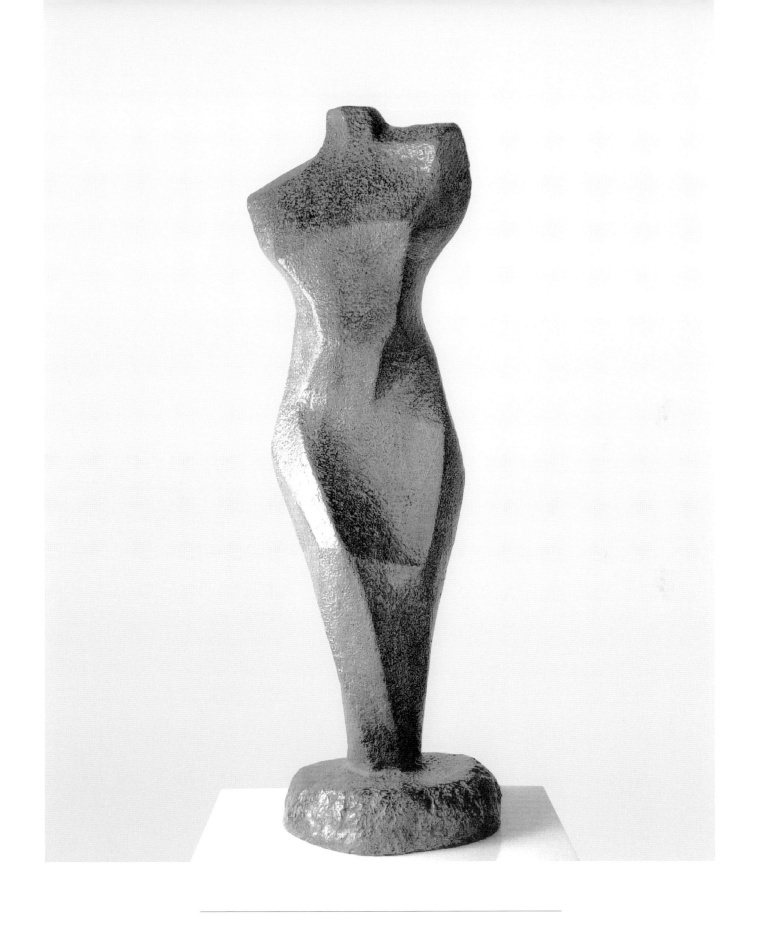

Figure (Rosa) 1965 Bronze Cast. H 41 ½" W 12 ½" (104 x 32 cm)
Sculpture No.23A (ED 9)

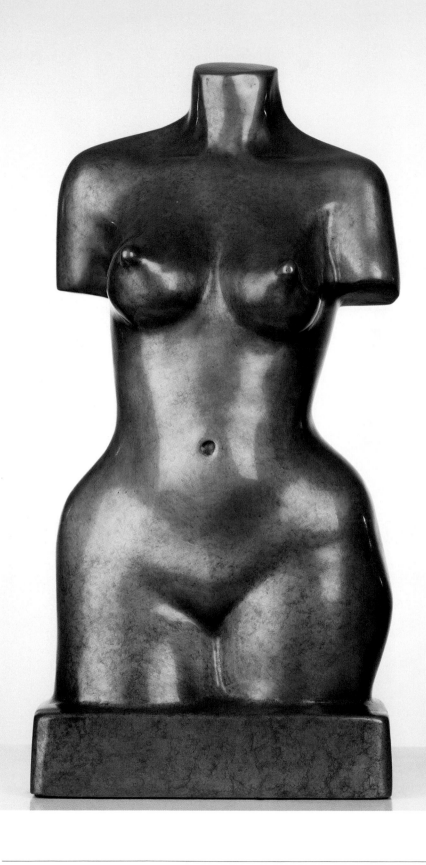

Torso of Electra 1966 Bronze Cast. H 21 W 9 ¾" D 5 ¾" (53 x 25 x 14.5 cm)
Sculpture No.30A (ED 9)

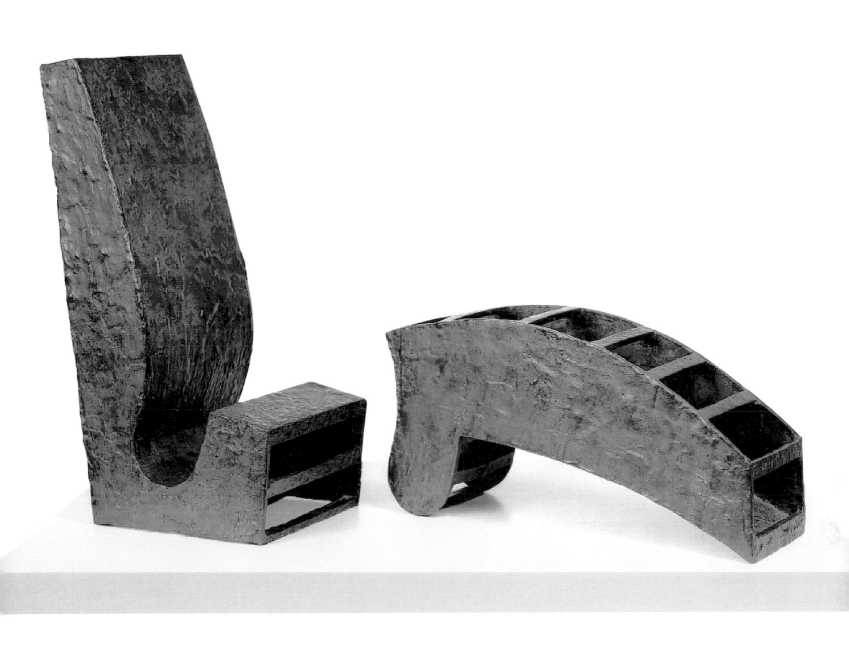

Unity 1967 Bronze Cast. H 17 ³/₄" W 13 ½" D 5 ⅛" (45 x 34 x 13 cm)
Sculpture No.51 (ED 3)

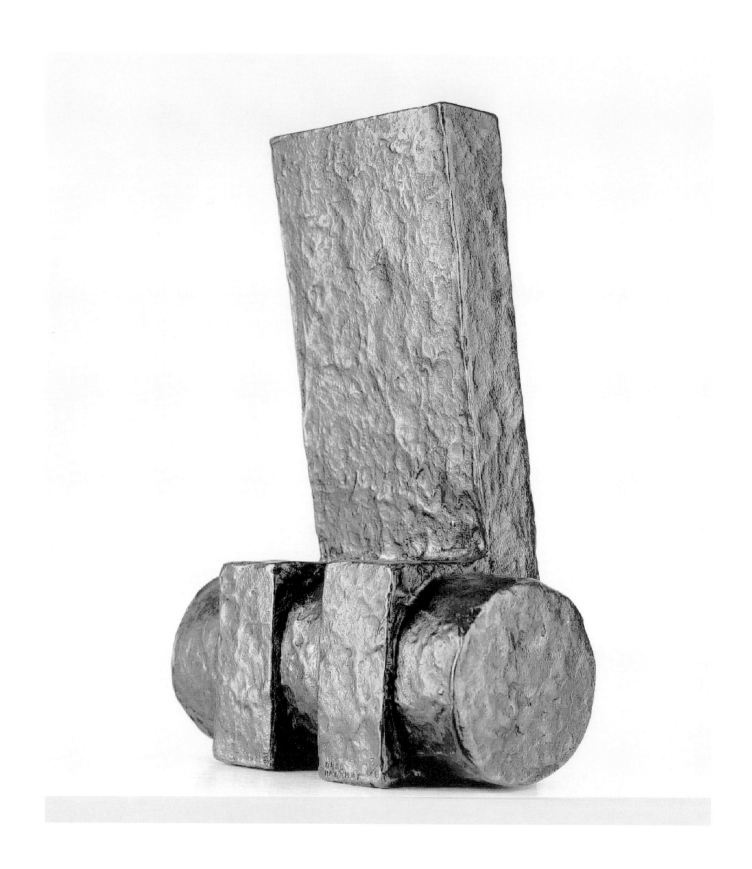

Upwards 1967 Bronze Cast. H 9 ¾" W 6 ¼" D 3 ¼" (25 x 16 x 8 cm)
Sculpture No.45 (ED 6) Collection: Ralph & Sylvia Milrod

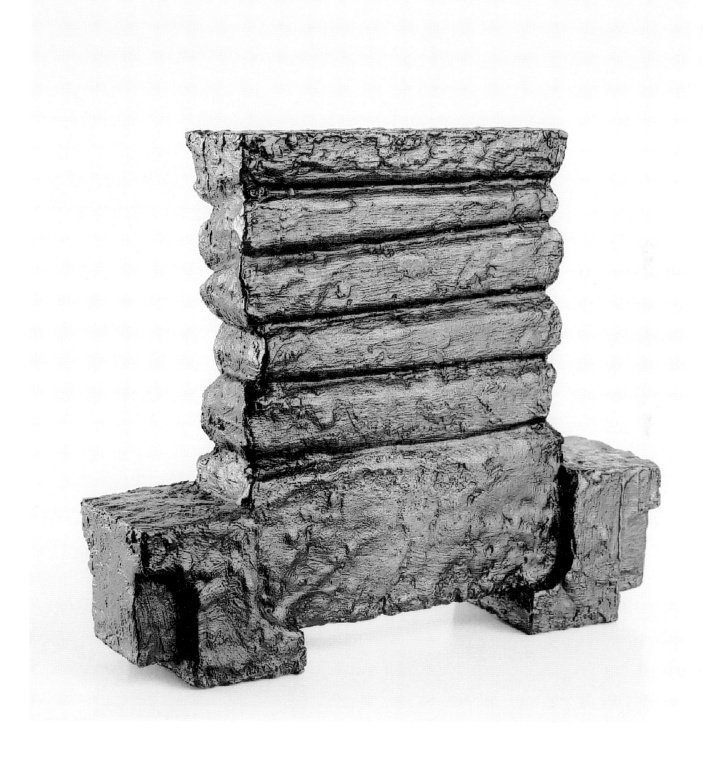

Altar (Homage to my Father) 1967 Bronze Cast. H 10 ½" W 11 ¾" D 3 ⅛" (26 x 30 x 8 cm)
Sculpture No.48 (ED 6) Private Collection: New York City

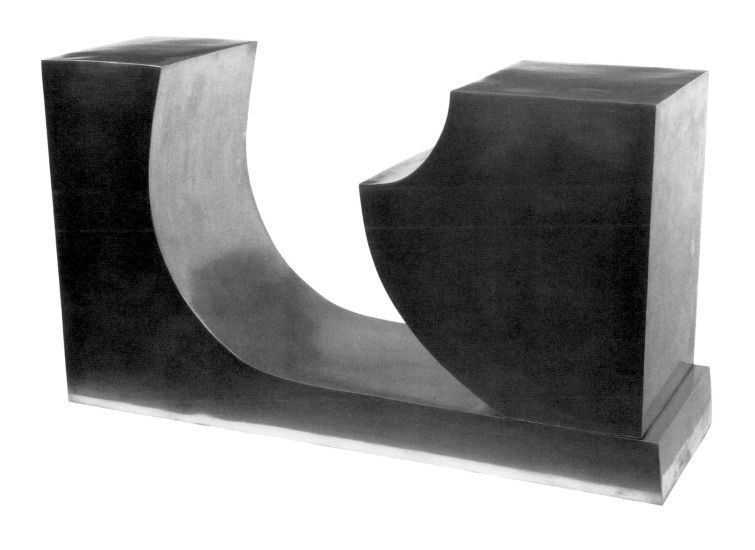

Song of Songs, Father and Son 1968–69 Bronze Cast. H 13 ¼" W 25 ¼" D 7 ¾" (33.5 x 64 x 19.5 cm)

Sculpture No.61 (ED 8) Collection: Chase Manhattan Bank, New York City and Florence & Gil Aronowitz

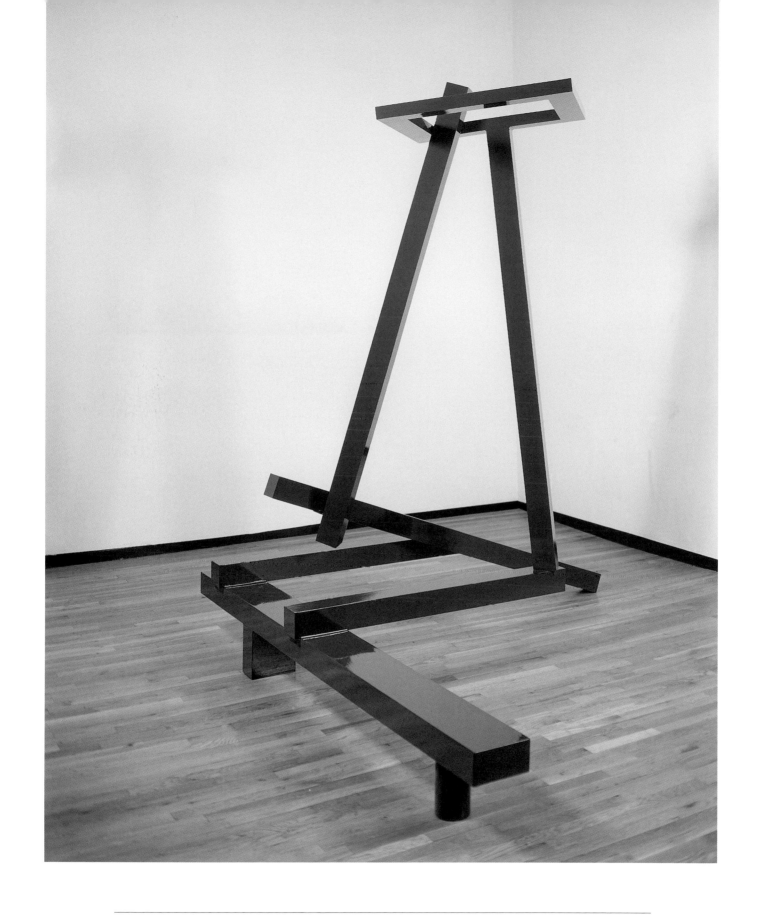

Sky Window 1973 Welded Aluminum, Painted Blue. H 100" W 90" D 84" (2.54 x 2.29 x 2.18 m)
Sculpture No.80 (Unique) Collection: Lynn & Jeffrey Slutsky, Nevele Country Club, Ellenville, New York

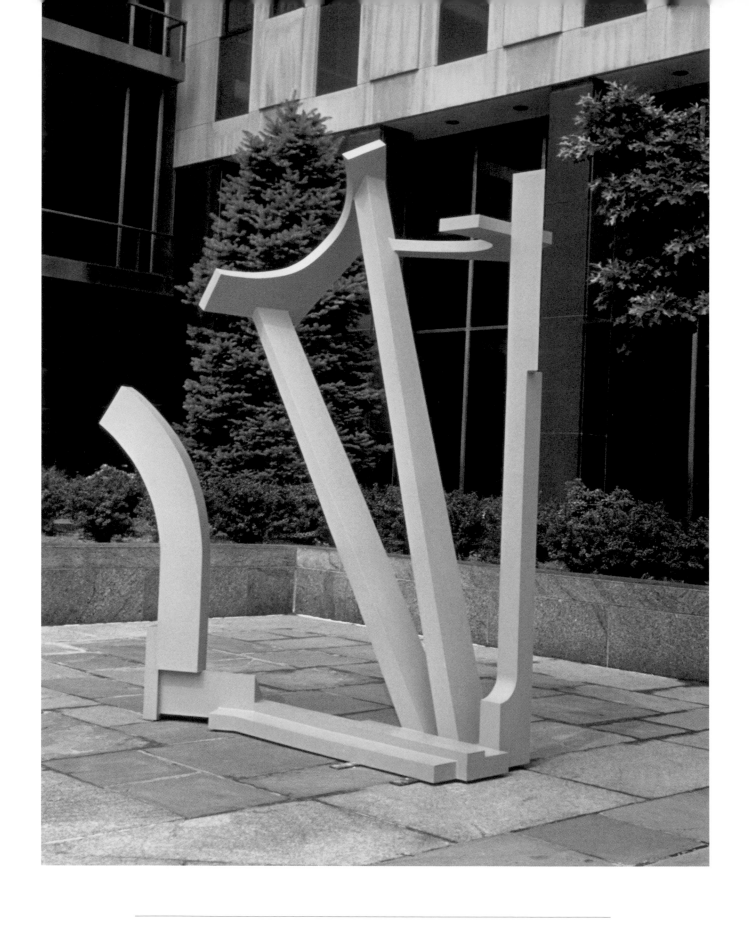

Sight 1973 Welded Aluminum, Painted Yellow. H 108" W 91" D 48" (2.74 x 2.31 x 1.22 m)
Sculpture No.83 (Unique) Private Collection: San Francisco, California

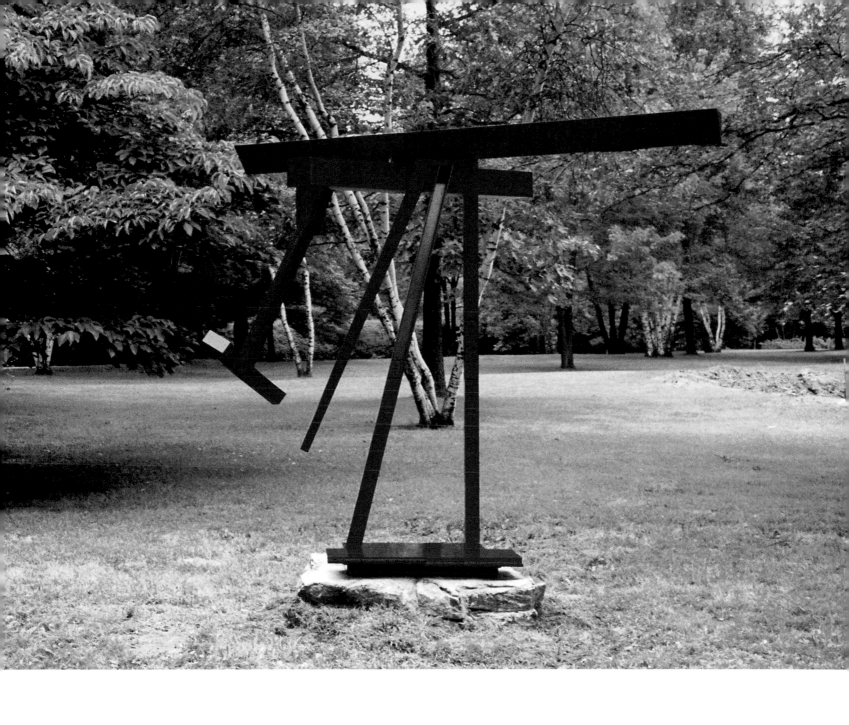

Galil 1973 Welded Aluminum, Painted Red. H 92" W 108" D 87" (2.34 x 2.74 x 2.21 m)
Sculpture No.82 (Unique) Collection: Martin & Selma Rosen, Greenwich, Connecticut

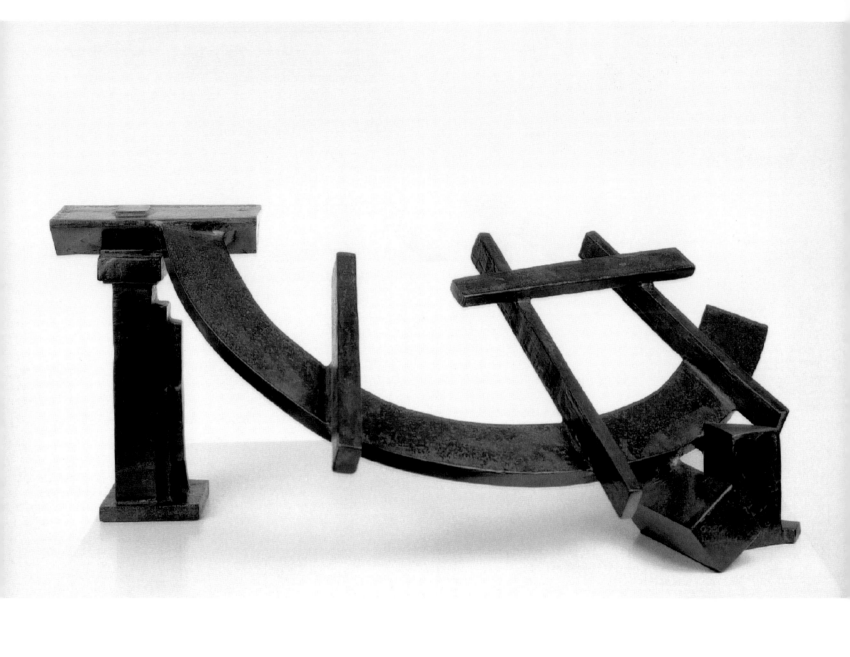

Sands 1974 Bronze Cast. H 10 ½" W 26" D 17" (26.5 x 66 x 43 cm)

Sculpture No.86 (ED 5) Collection: Lucill & Brian Murray, Michael Spett and Mr. & Mrs. Ted Millon

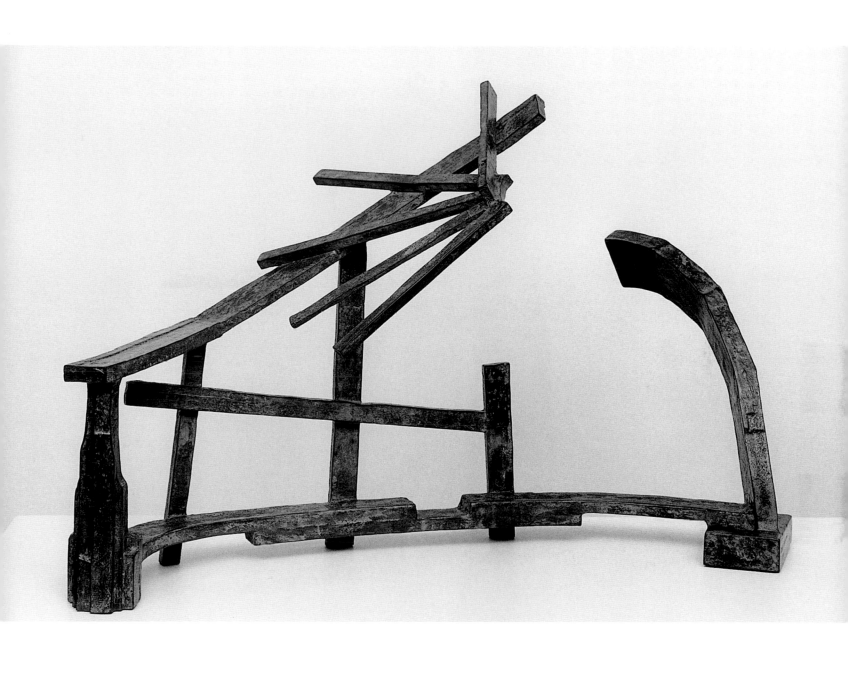

Nomad Star 1975 Bronze Cast. H 17" W 27" D 14" (43 x 69 x 36 cm)
Sculpture No.93 (ED 5)

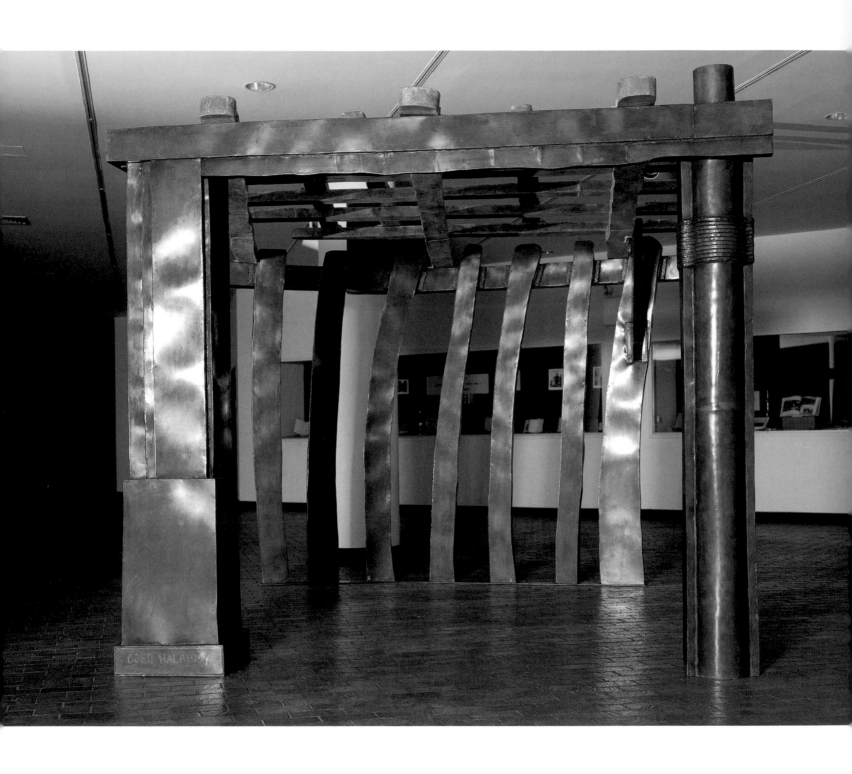

Sukkah 1975-79 Welded Bronze. H 106" W 124" D 138" (2.7 x 3.15 x 3.5 cm)
Sculpture No.94 (Unique) Participatory Enviornment Sculpture Collection: Hebrew Union College,
Jerusalem, Israel. Gift of Edith S. Peiser

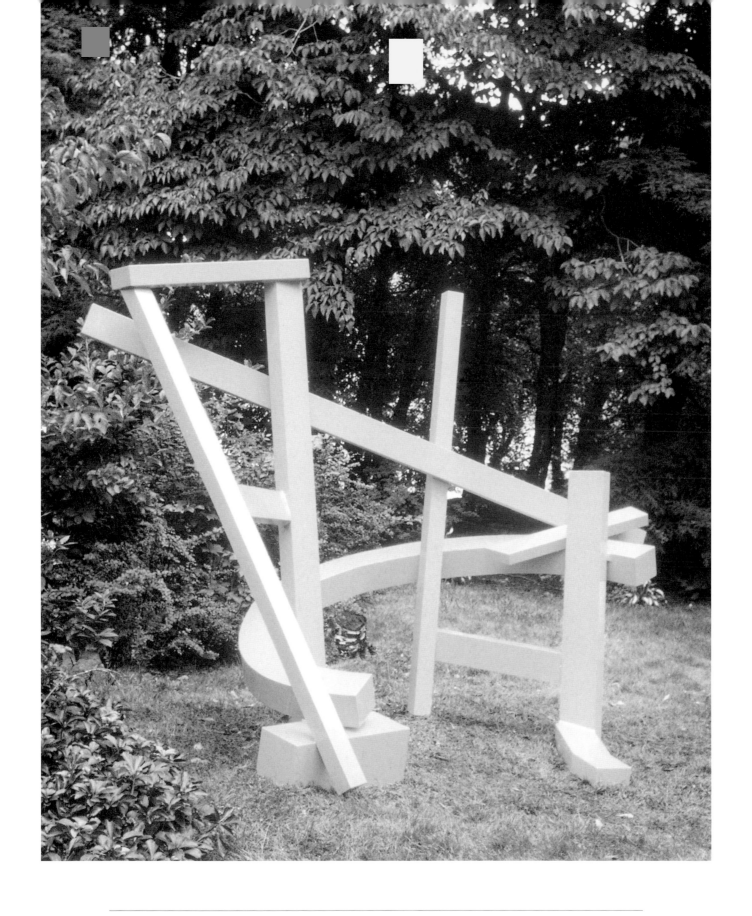

Embrace 1975–79 Welded Aluminum, Painted Yellow. H 78" W 105" D 70" (1.38 x 2.66 x 1.78 m)
Sculpture No.92 (Unique) Collection: Alfred & Hanina Shasha, Scarsdale, New York

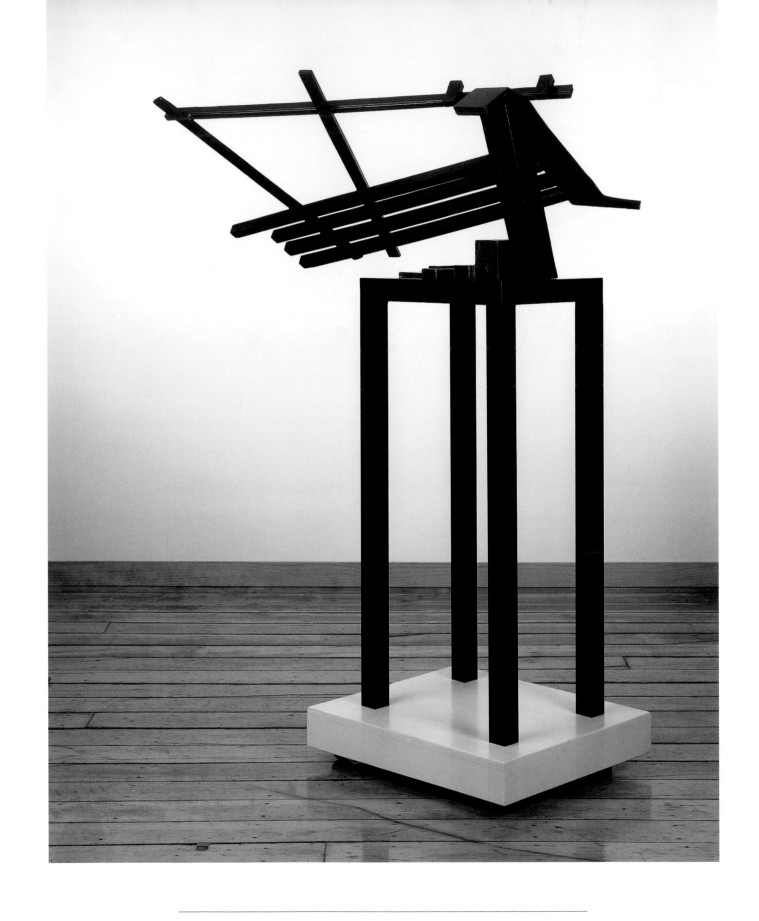

Gliding 1975 Bronze Cast. H 63 ¼" x W 47 x D 39" (160.5 x 120 x 99 cm)

Sculpture No.91 (ED 3) Collection: Alexander F. Milliken, New York

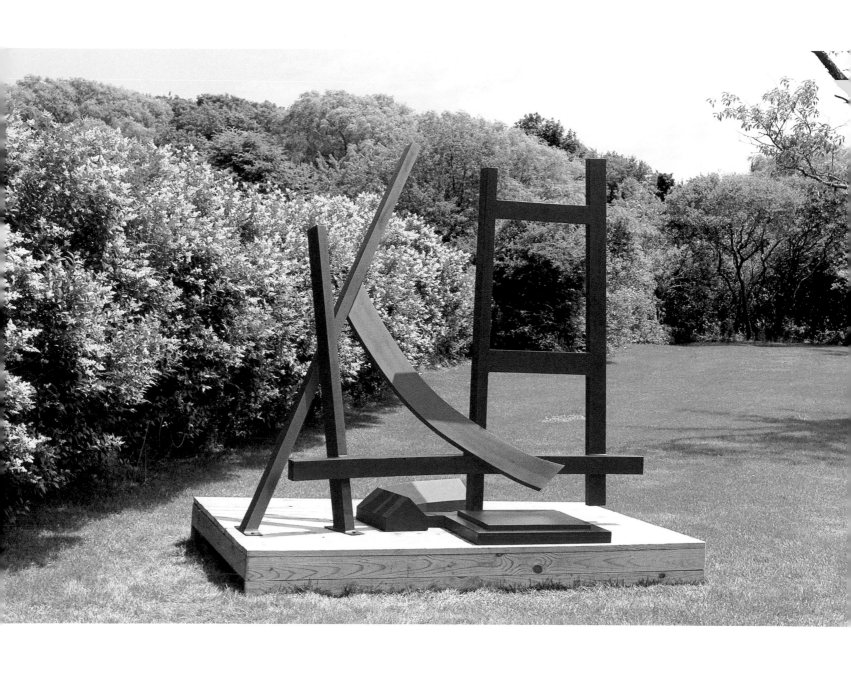

Skyward 1975–84 Welded Aluminum, Painted Red. H 108" W 116" D 72" (2.75 x 2.95 x 1.83 m)
Sculpture No.90 (Unique) Private Collection: Water Mill, New York

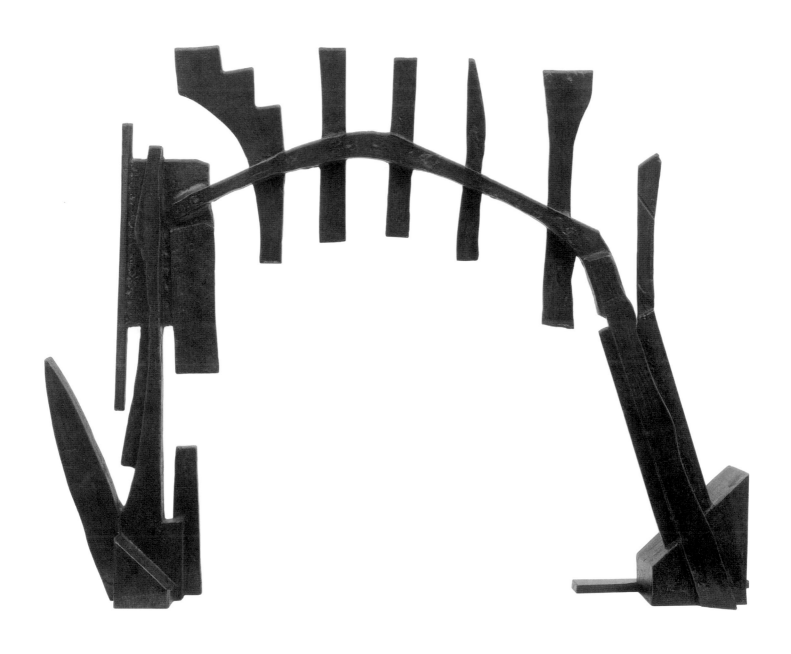

Known by the Gate 1976 Bronze Cast. H 26" W 33 ½" D 5" (66 x 85 x 13 cm)
Sculpture No.100 (ED 5)

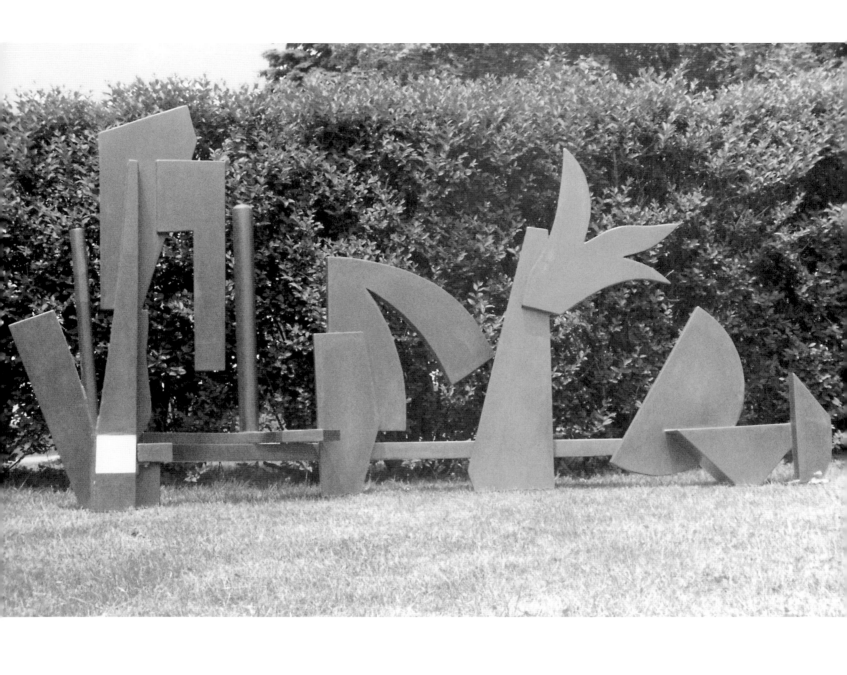

Mirage 1976 Welded, Cor-Ten Steel. H 69" W 132" D 34" (1.75 x 3.35 x 0.85 m)
Sculpture No.101 (Unique) Collection: Alexander F. Milliken, Sagaponack, New York

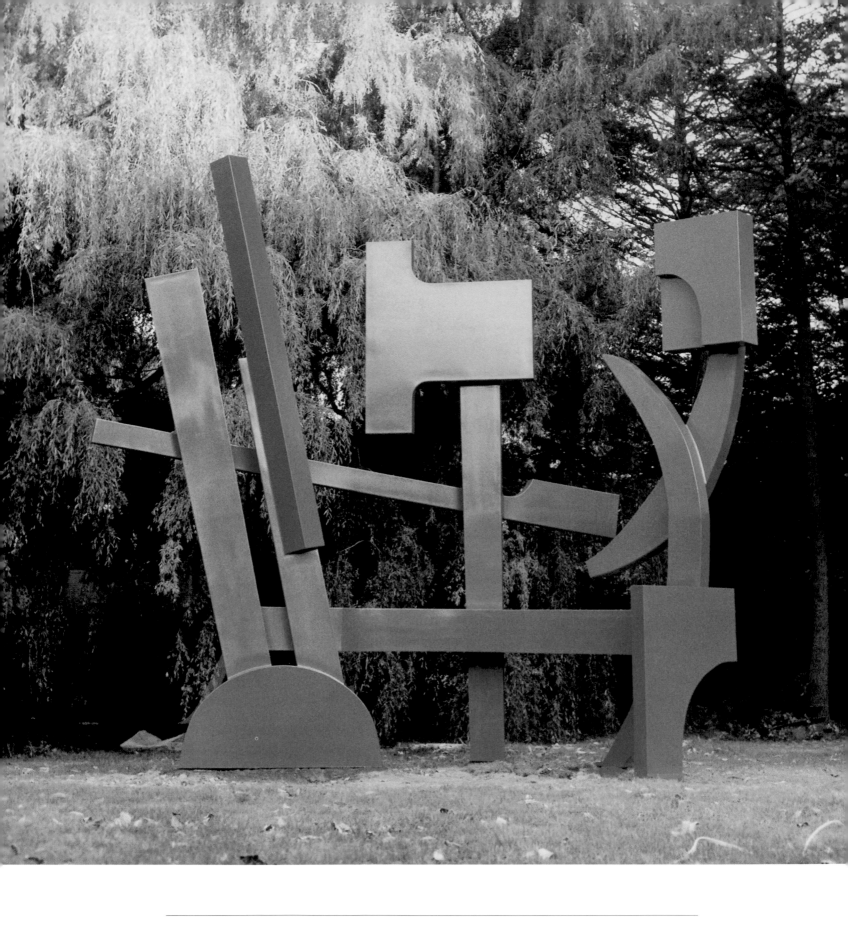

Blue Party 1976–82 Welded Aluminum, Painted Blue. H 180" W 192" D 78" (4.6 x 4.30 x 2 m)
Sculpture No.98 (Unique) Collection: The Aldrich Museum of Contemporary Art, Ridgefield, Connecticut

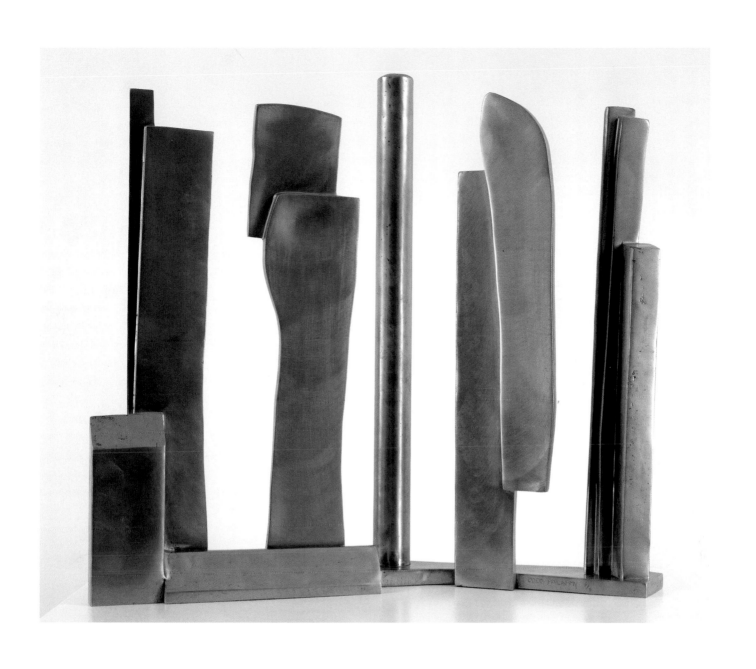

Family (Study) 1978 Nickel Bronze Cast. H 26" W 29" D 8" (66 x 74 x 20 cm)
Sculpture No.115 (S) (ED 5) Collection: Solomon R. Guggenheim Museum, New York City.
Ellen & Robert Shasha, Nancy & David Moche, Sidney Milgrim, Gallery 3, Palm Beach, Florida

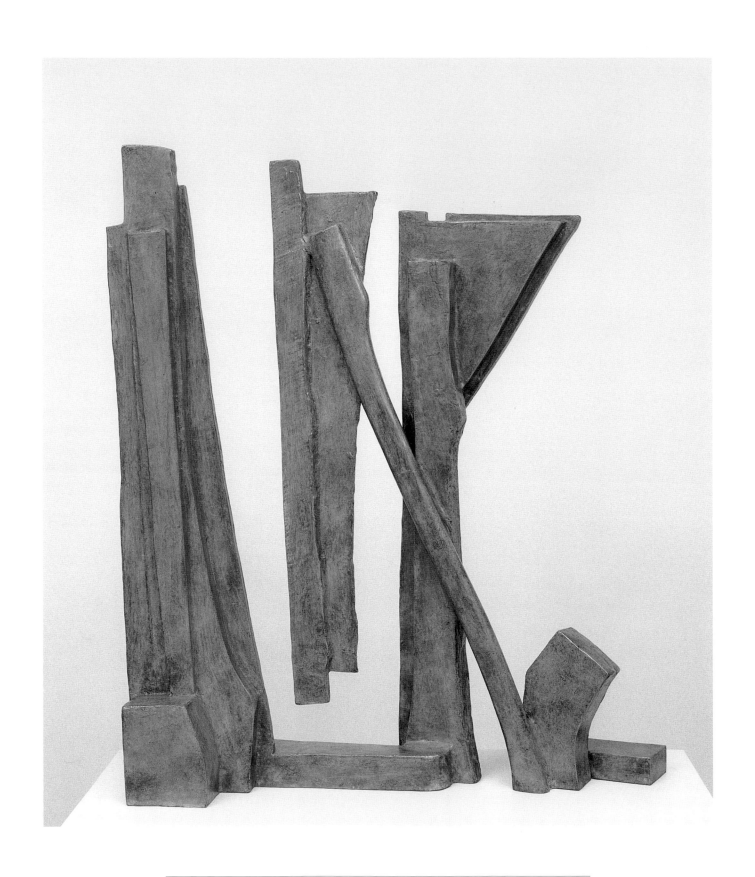

Walk Straight 1979 Bronze Cast. H 31" W 25" D 7" (79 x 63 x 18 cm)
Sculpture No.131 (ED 5) Collection: Byer Museum of the Arts, Evanston, Illinois

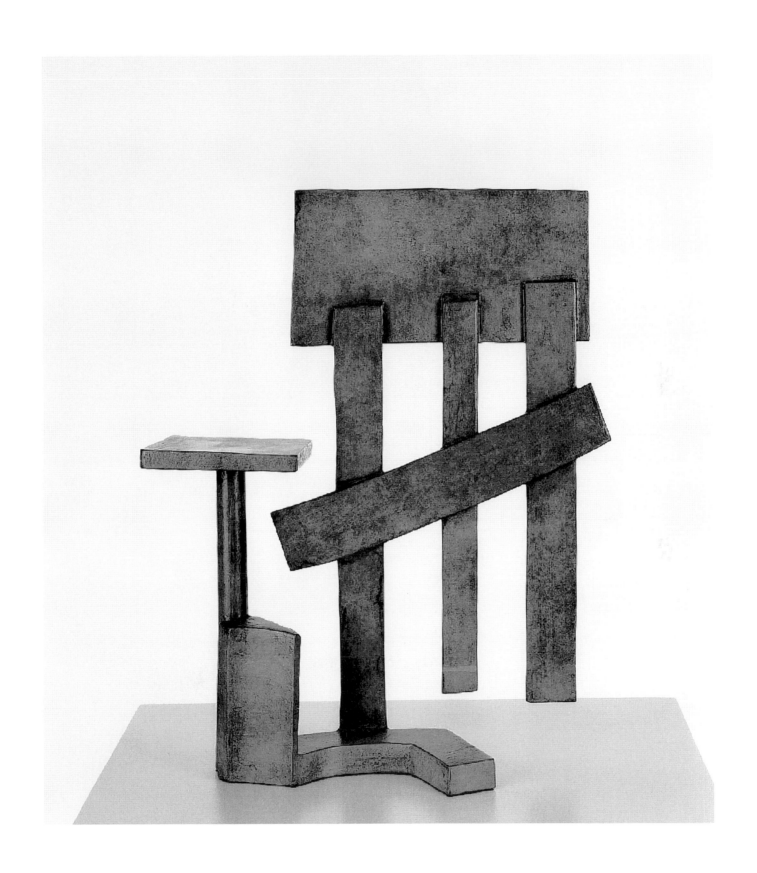

He Stands Up 1979 Bronze Cast. H 26" W 20" D 7" (66 x 51 x 18 cm)
Sculpture No.124 (ED 5)

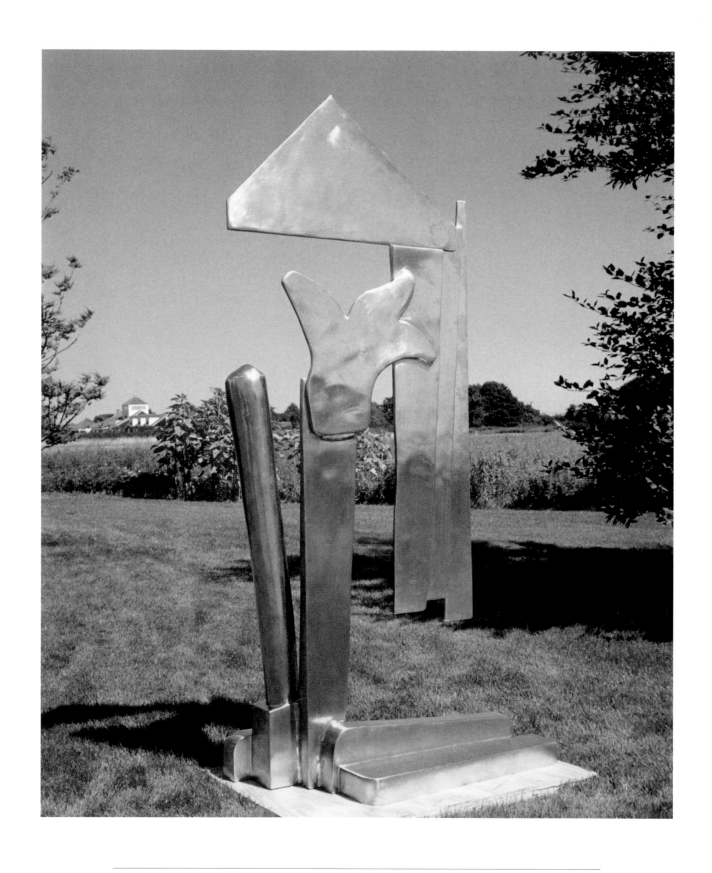

Fata Morgana 1980–87 Nickel Bronze Cast. H 101" W 39" D 25" (256 x 99 x 64 cm)
Sculpture No.132 (ED 3) Collection: Louis K. & Susan Pear Meisel, Sagaponack, New York

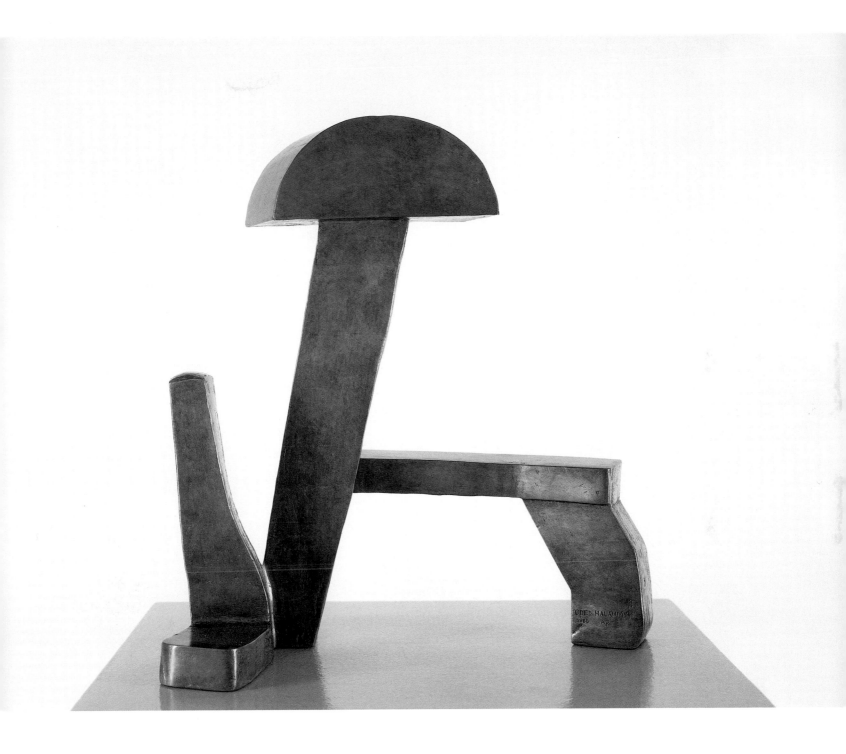

Moonscape 1980 Bronze Cast. H 21" W 20" D 10" (53 x 51 x 25 cm)
Sculpture No.130 (ED 3) Collection: Frederick & Elizabeth Singer and Alice & John Goldsmith

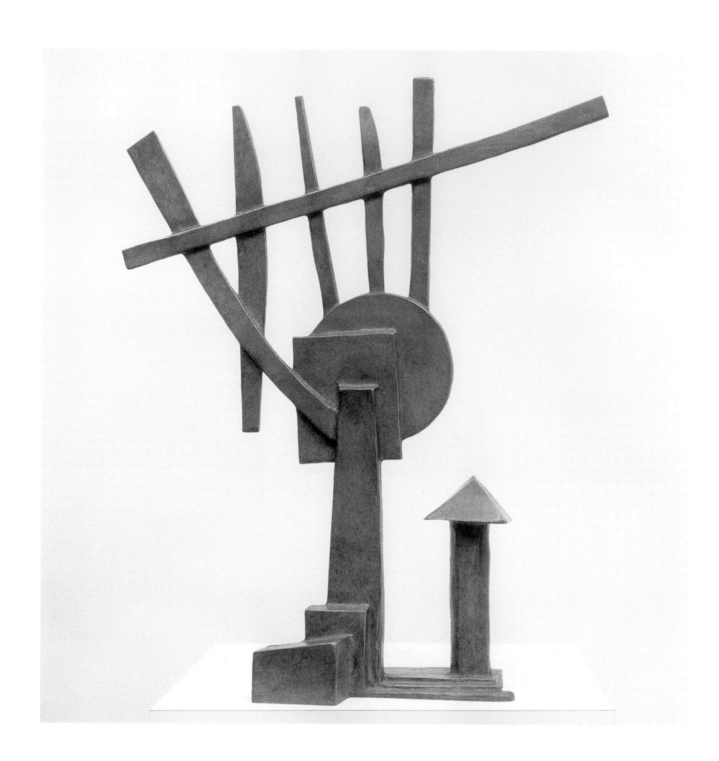

A Festive Place 1981 Bronze Cast. H 28" x W 19" x D 7.5" (71 x 48 x 19 cm)

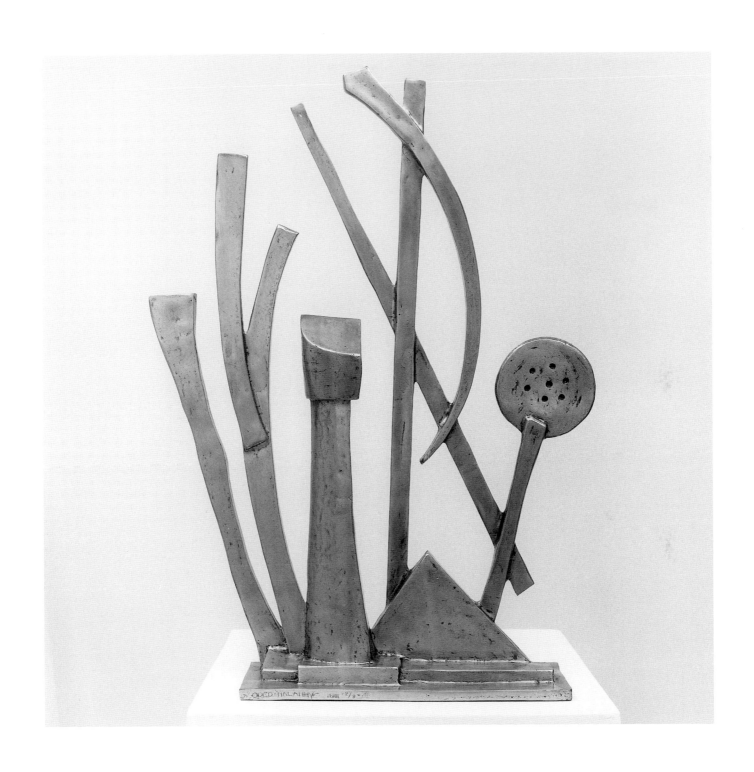

A Place in the East 1981 Nickel Bronze Cast. H 26" W 19" D 5" (66 x 48 x 13 cm)
Sculpture No.142 (ED 9) Collection: Herbert, F. Johnson Museum of Art, Cornell University,
Ithaca, New York

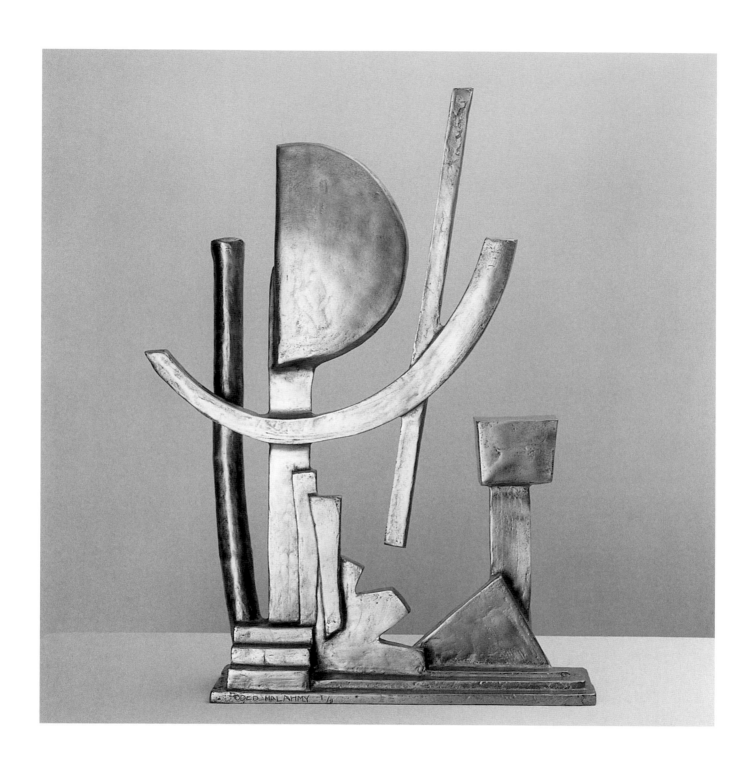

Silver Moon 1981 Nickel Bronze Cast. H 22 ½" W 17" D 4 ½" (57 x 43 x 11.5 cm)
Sculpture No.139 (ED 9) Collection: Robert S. Moor, James C. Kaplan, Stephanie Later,
Lea & Henry Flescher and Martin Staddard

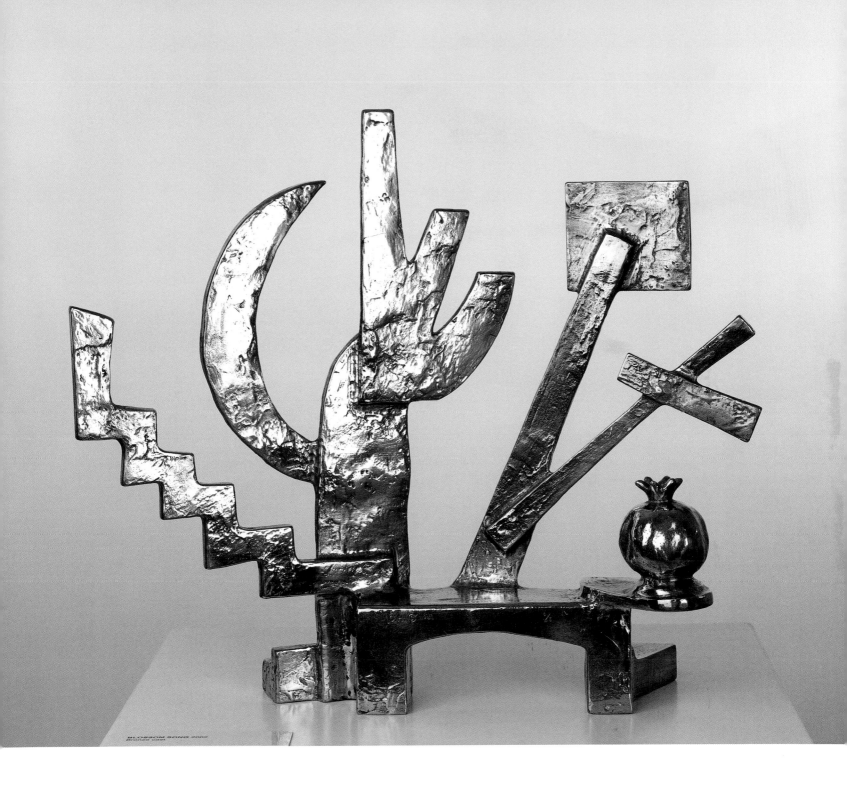

Oriental Place 1981 Nickel Bronze Cast. H 21" W 24" D 8" (54 x 61 x 20 cm)
Sculpture No.157 (ED 5) Collection: Elliott Meisel and Theodore & Anne Oshman

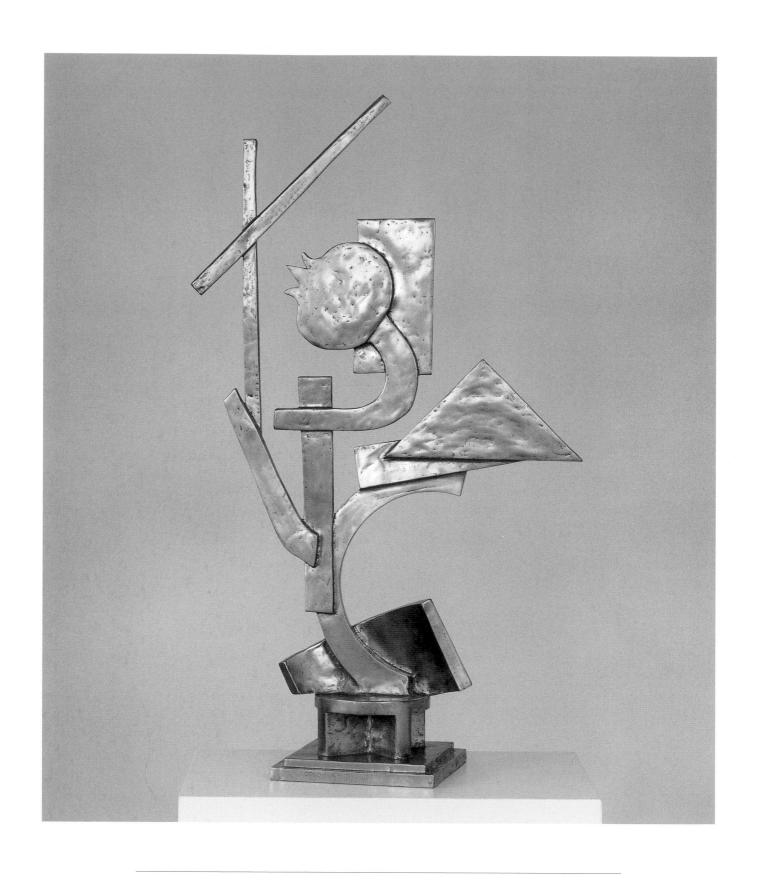

Pomegranate Lady 1982 Nickel Bronze Cast. H 41 ½" W 24" D 10" (104 x 61 x 25 cm)
Sculpture No.151 (ED 5) Collection: Pamela Helfman

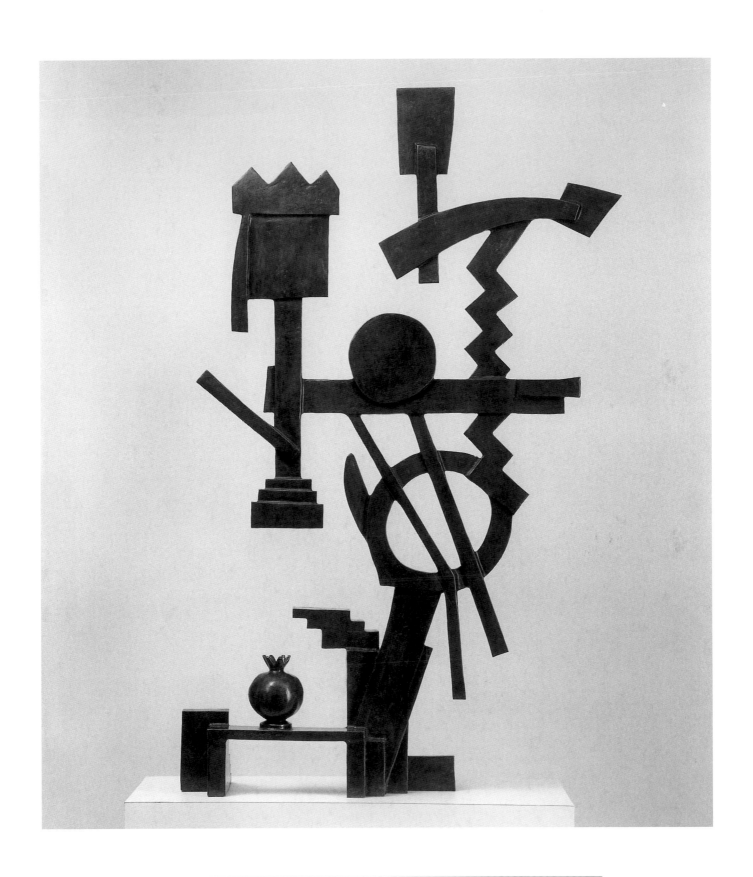

More East than West 1983 Bronze Cast. H 55" W 34" D 10" (140 x 86 x 25 cm)
Sculpture No.155 (ED 3) Private Collection: Los Angeles, California

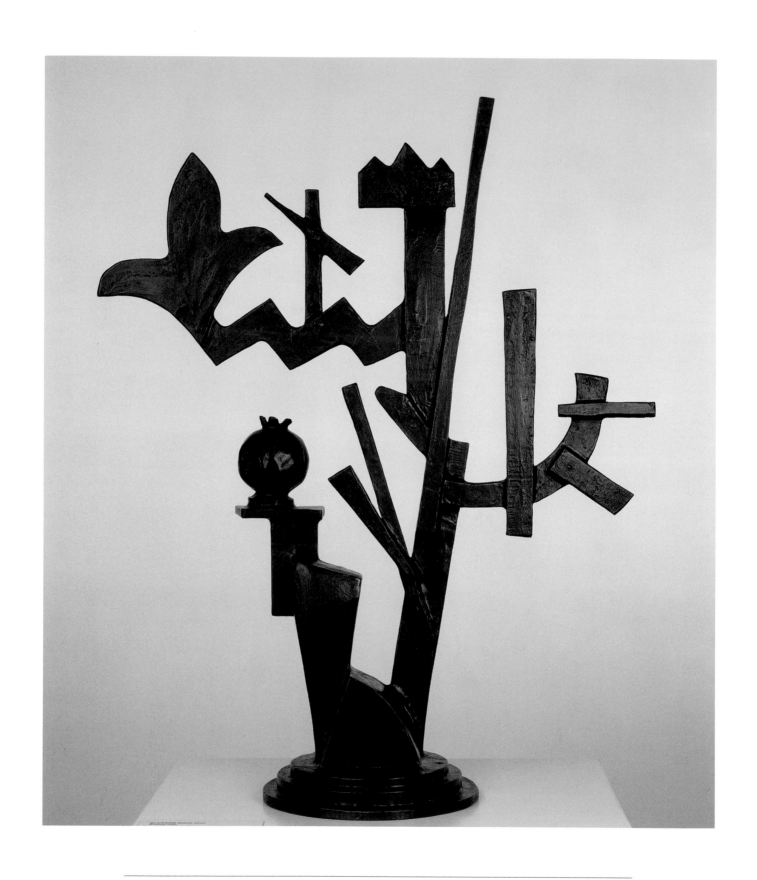

Pomegranate King with Flower 1983 Bronze Cast. H 36" W 29" D 11" (91 x 74 x 28 cm)
Sculpture No.154 (ED 5)

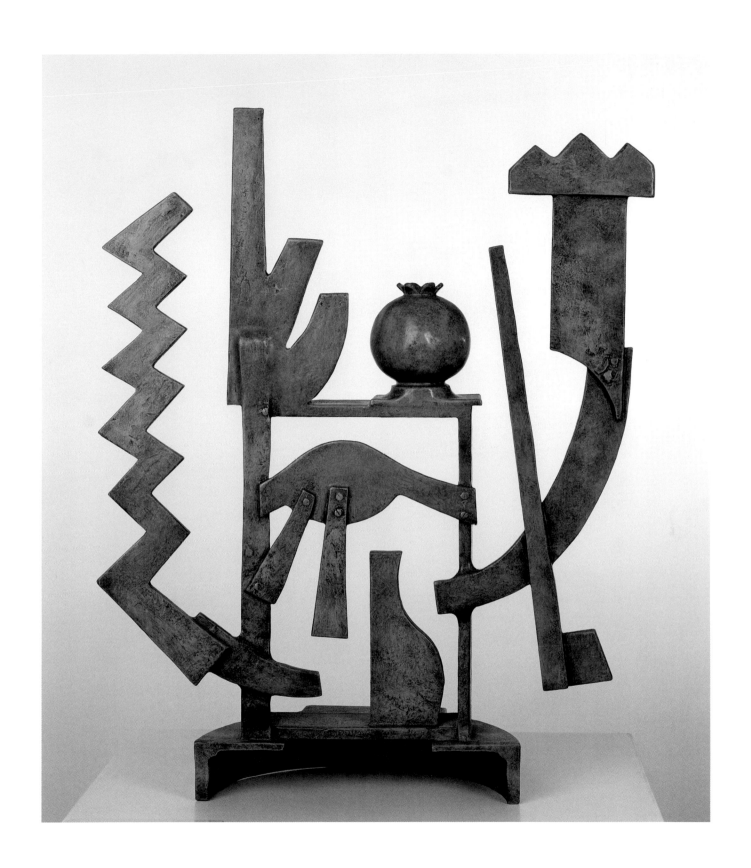

Pomegranate Drinks Water 1983 Bronze Cast. H 28 ½" W 23" D 7 ½" (72 x 58 x 19 cm)
Sculpture No.153 (ED 5) Collection: Regine & Reuben Ginsberg

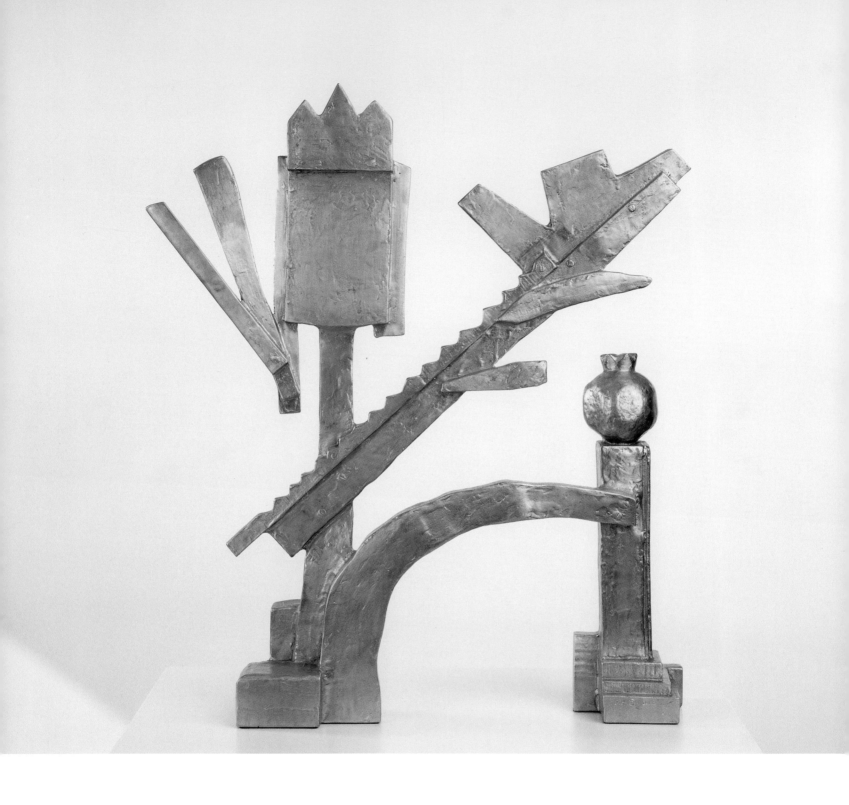

Where We Meet 1983 Aluminum Cast. H 27" W 19 ½" D 5" (68 x 49 x 13 cm)
Sculpture No.216 (ED 5)

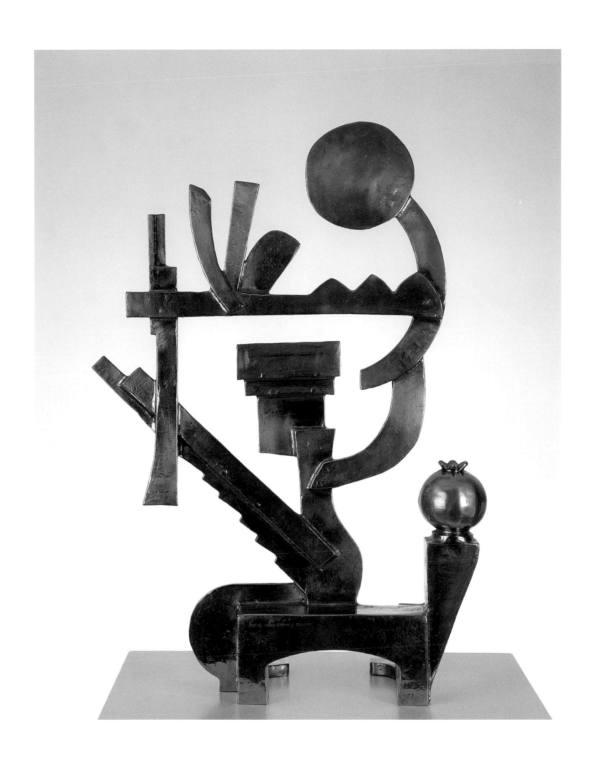

Silver Pomegranate Moon 1983 Nickel Bronze Cast. H 34 ½" W 23" D 9" (87.5 x 58 x 23 cm)
Sculpture No.152 (ED 5) Collection: Alan & Ann Barton

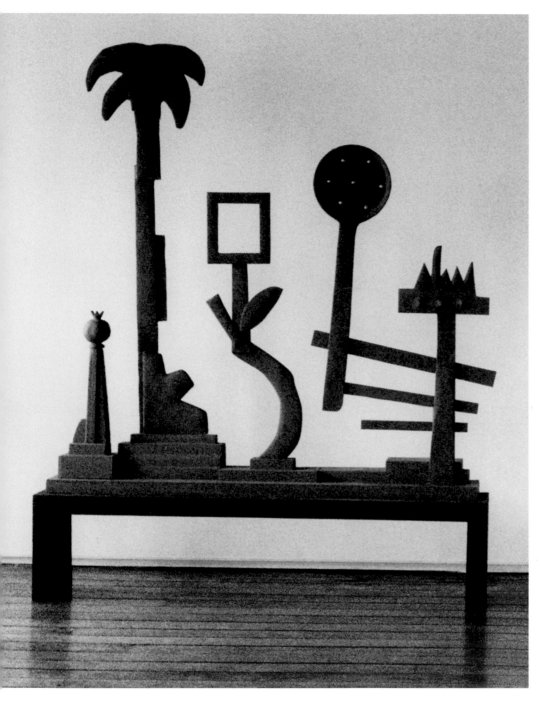

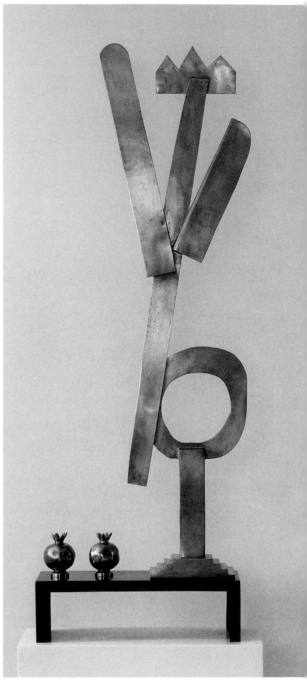

Left: **Homemade** 1984–86 Bronze Cast. H 88" x W 72" x D 12" (223 x 183 x 30 cm)
Sculpture No.161 (ED 3) Private Collection: Boca Raton, Florida

Right: **For a Good Day** 1984 Bronze and Nickel Bronze Cast. H 80" W 27" D 11 ½" (203 x 69 x 29 cm)
Sculpture No.162 (ED 3) Collection: Ellen & Robert Shasha, New Rochelle, New York

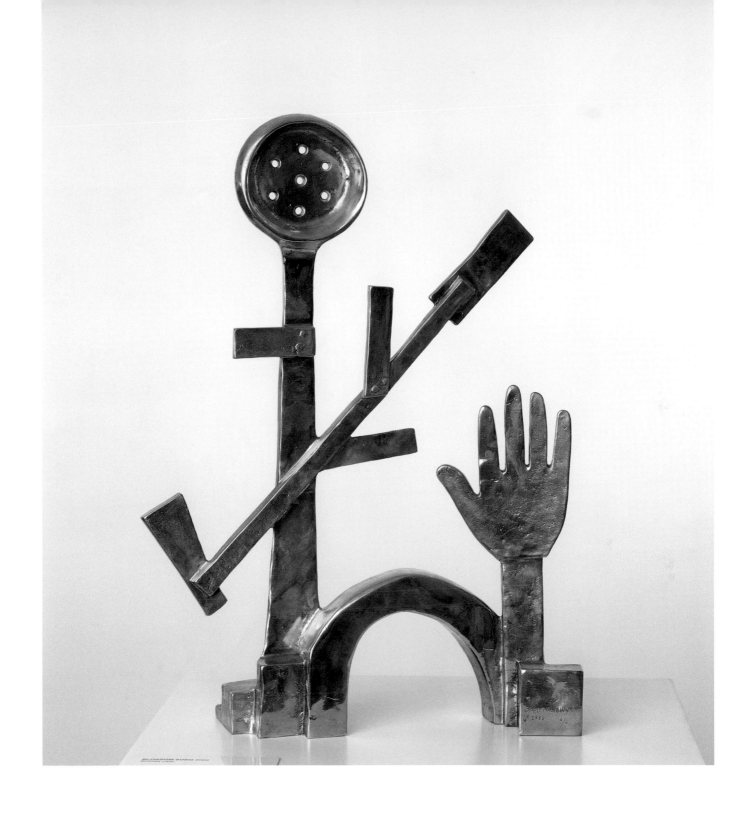

Protection 1985 Nickel Bronze Cast. H 27" W 19" D 6" (69 x 48 x 15 cm)
Sculpture No.163 (ED 5) Collection: Israel Museum, Jerusalem and Haskel & Ahuva Halahmy

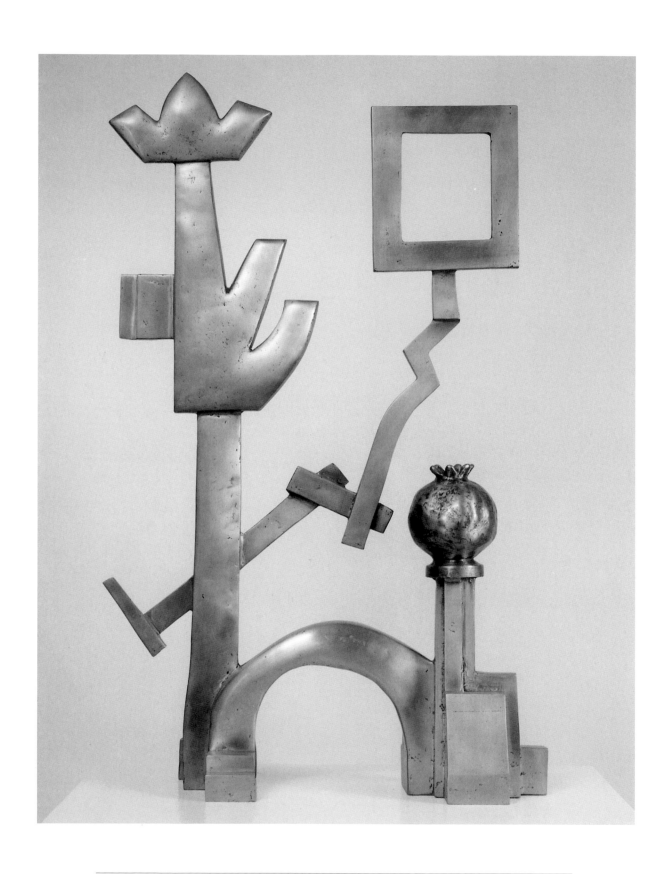

Royalty at the Gate 1985 Nickel Bronze Cast. H 31 ½" W 20" D 8" (80 x 51 x 20 cm)
Sculpture No.164 (ED 3) Collection: Israel Museum, Jerusalem

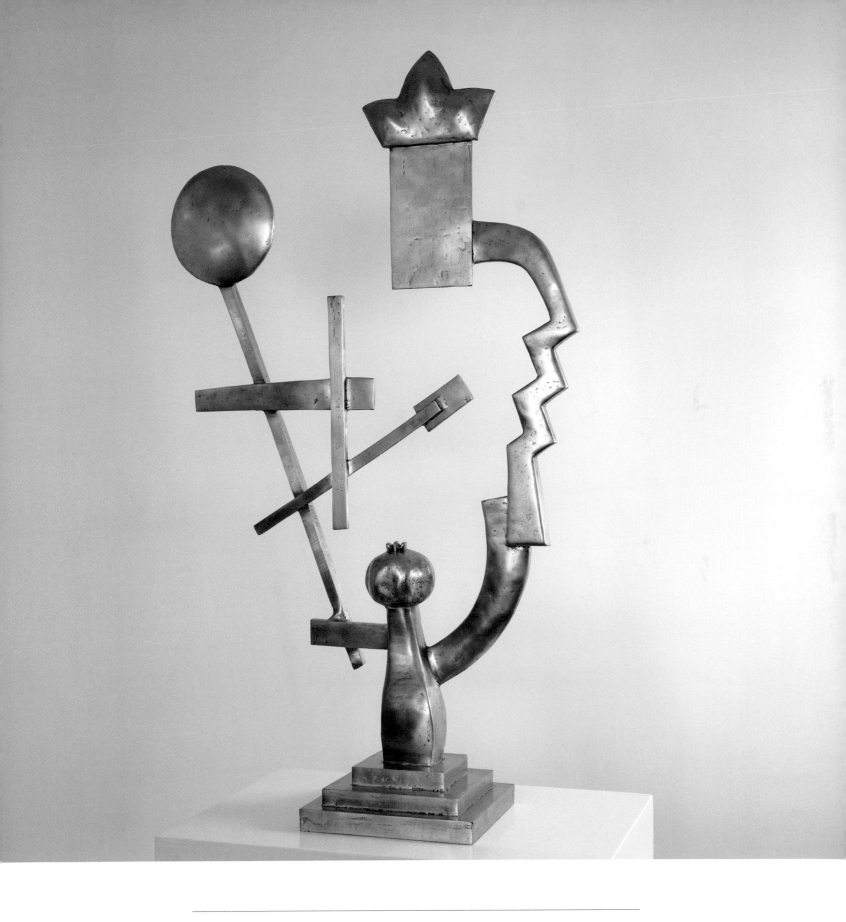

King in Bloom 1985 Bronze Nickel Cast. H 44" W 26" D 9¼" (112 x 66 x 23 cm)
Sculpture No.167 (ED 3) Collection: Richard Frank

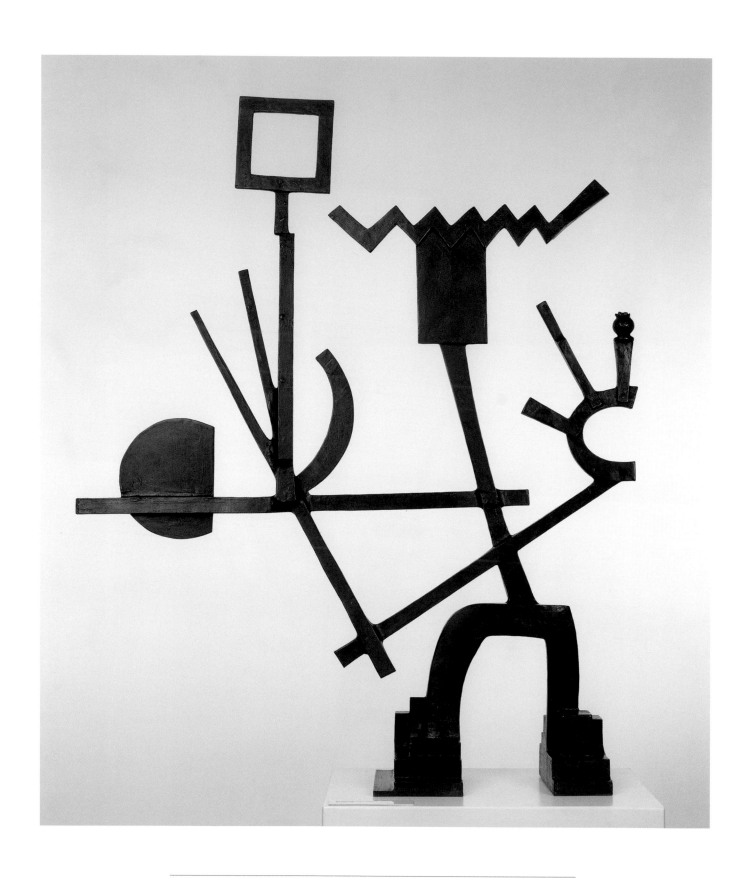

Royal Figure 1985 Bronze Cast. H 52" W 43" D 10" (132 x 109 x 25 cm)
Sculpture No.169 (ED 3) Collection: Harry & Marilyn Pelz

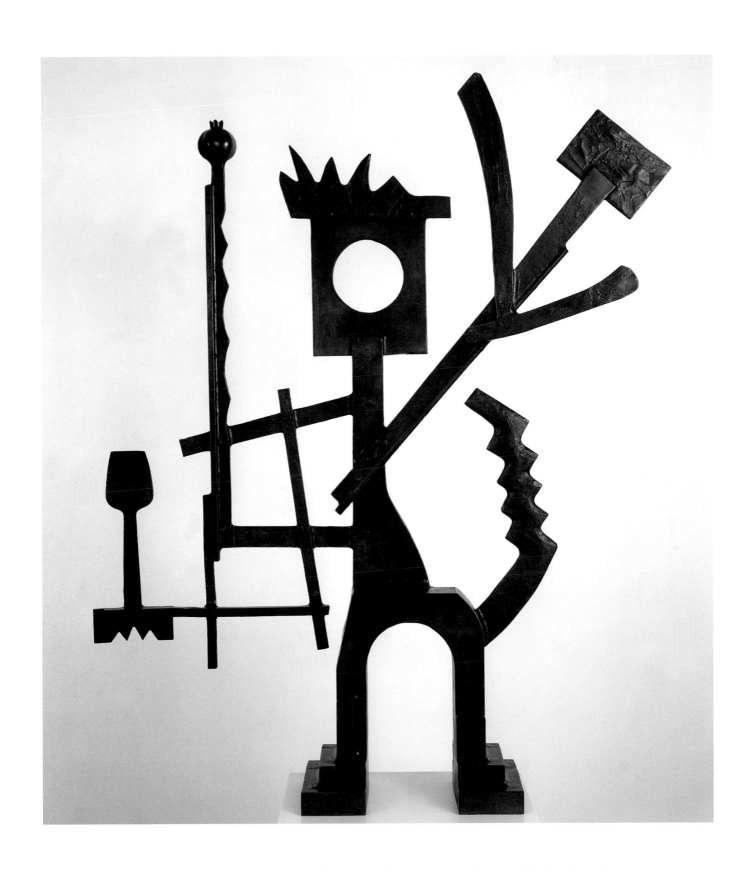

Nomad with Pomegranate 1985 Bronze Cast. H 58 ¾" W 60" D 9" (149 x 152 x 23 cm)
Sculpture No.184 (ED 3) Collection: Edward Millikow

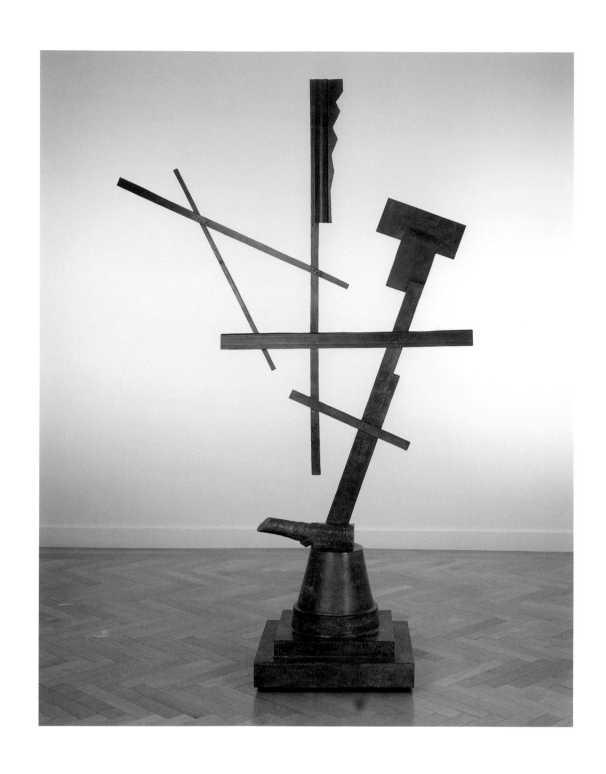

Rule and Line 1986 Bronze Cast. H 98" W 66" D 22" (250 x 167 x 56 cm)
Sculpture No.171 (ED 3)

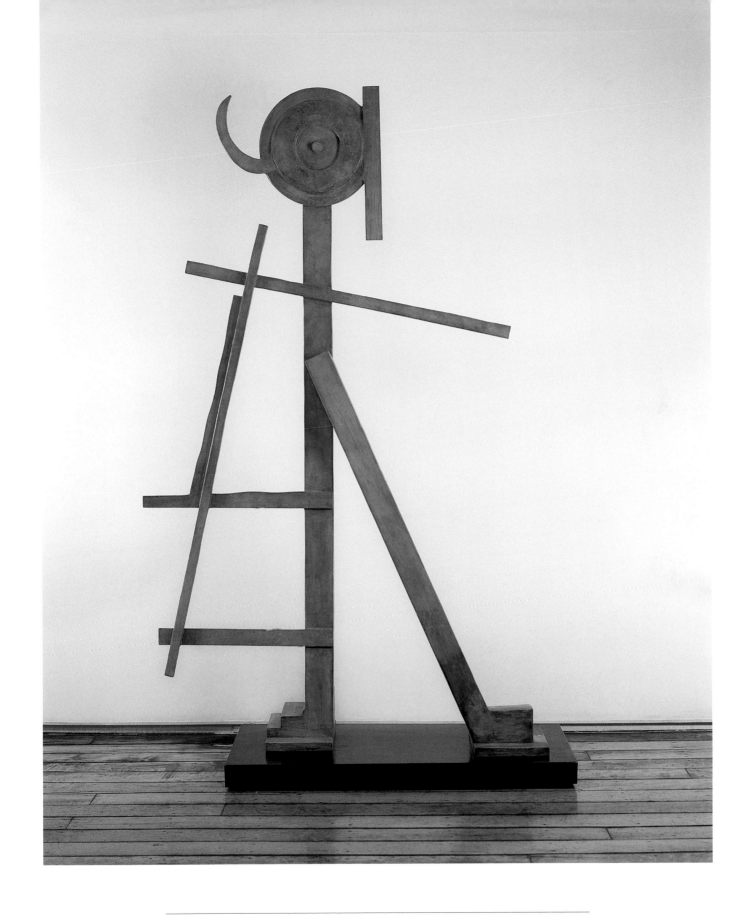

Noble Man 1986 Bronze Cast. H 100" W 72" D 24" (254 x 183 x 61 cm)
Sculpture No.170 (ED 3) Collection: Raymond Zimmerman, Brenton, Tennessee

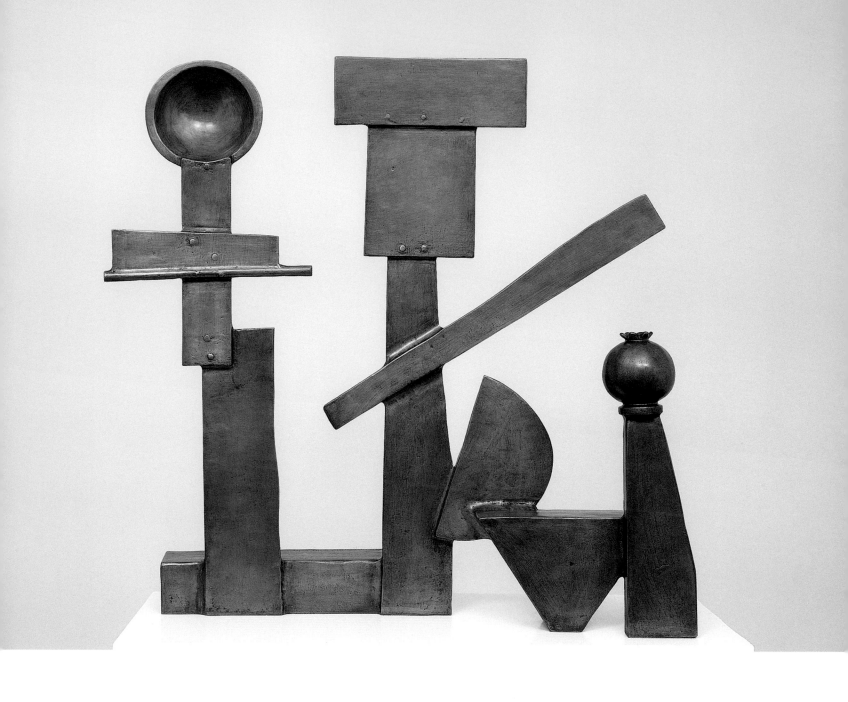

Imagine 1989 Bronze Cast. H 34" W 34 ½" D 10" (86 x 87 x 25 cm)
Sculpture No.181 (ED 5)

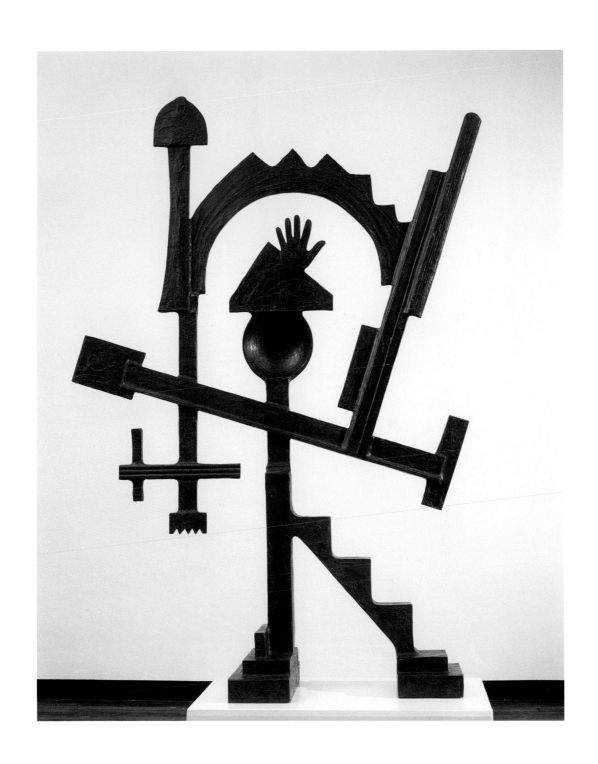

Touching Heaven 1990 Bronze Cast. H 87" W 57" D 17" (221 x 145 x 43 cm)
Sculpture No.190 (ED 3) Collection: The Chicago Athenaeum, International Sculpture Park,
Schaumburg, Illinois Installation: May 26, 2001

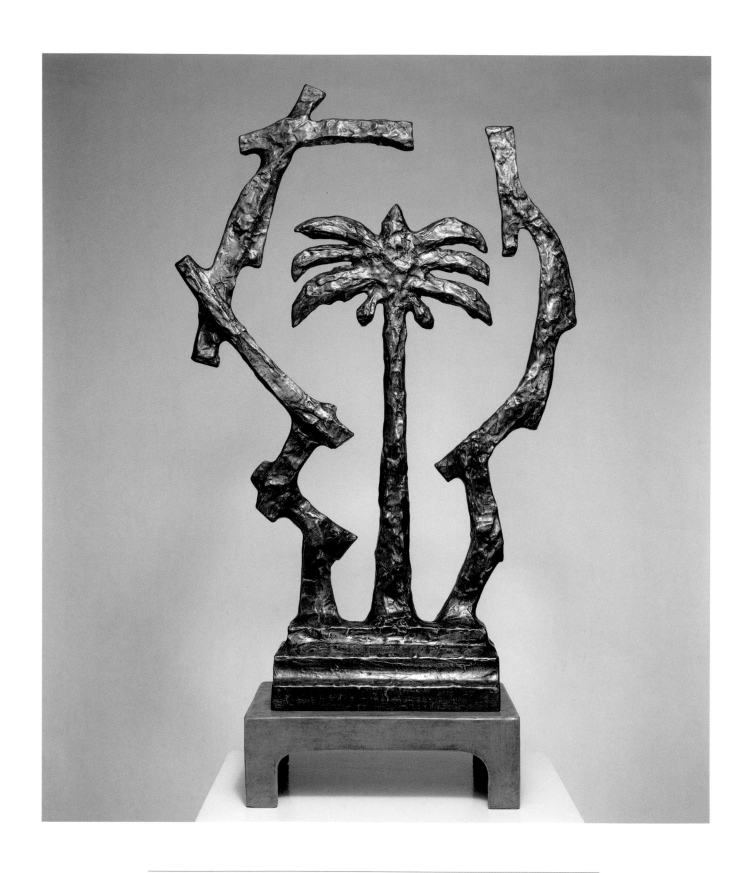

A Gift to a Palm Tree 1991 Bronze Cast. H 30" W 17" D 7 ½" (76 x 43 x 19 cm)
Sculpture No.196 (ED 9)

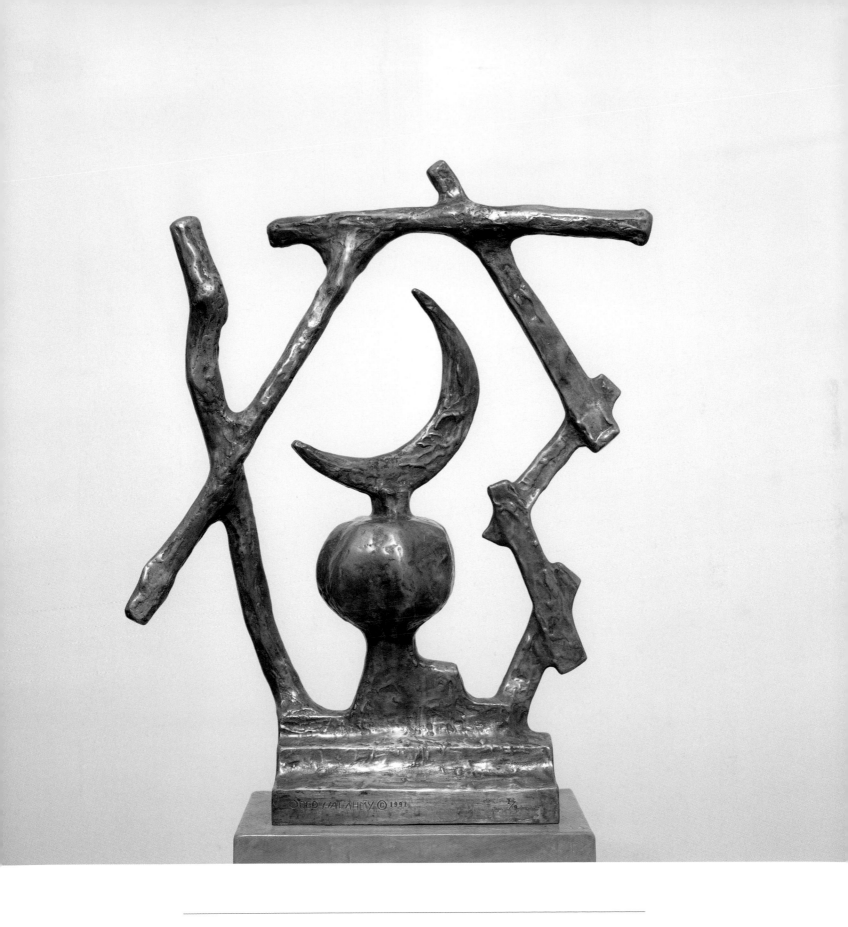

Pomegranate Moonrise 1991 Bronze Cast. H 23 ½" W 16" D 6" (60 x 40 x 15 cm)
Sculpture No.200 (ED 9)

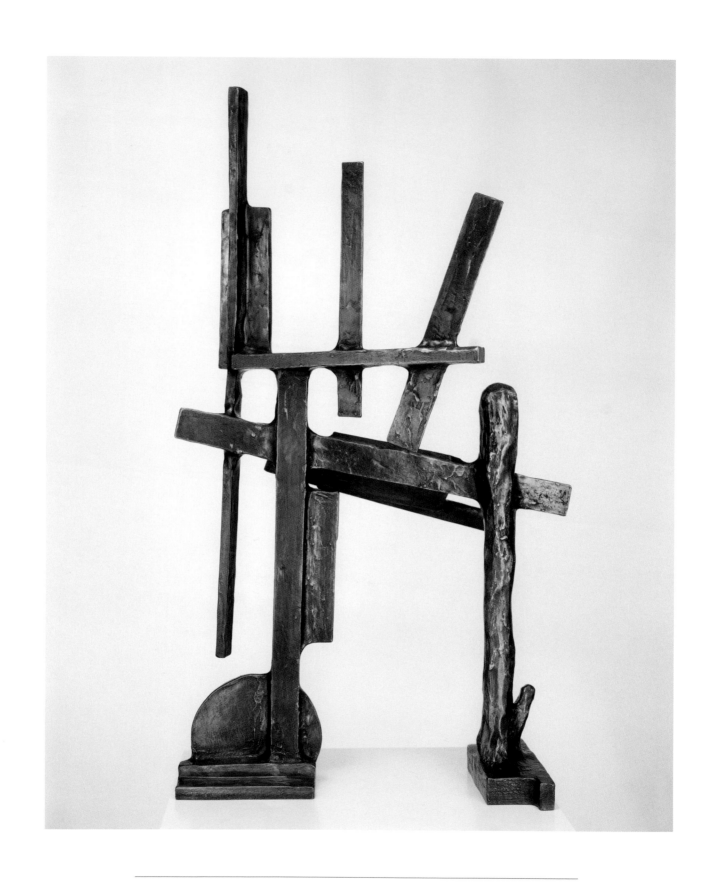

A Place for Peace 1992 Bronze Cast. H 37" W 21 ½" D 8 ½" (94 x 54 x 21 cm)
Sculpture No.206 (ED 5)

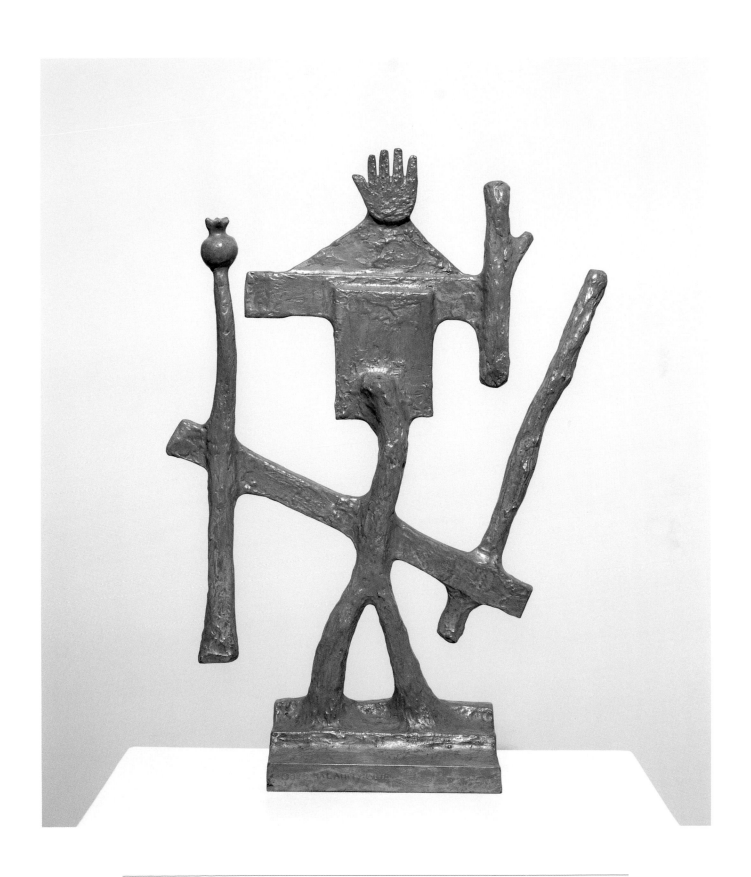

East and West in my Hand 1992 Bronze Cast. H 23 ½" W 17 ½" D 5 ½" (60 x 44 x 14 cm)
Sculpture No.203 (ED 9)

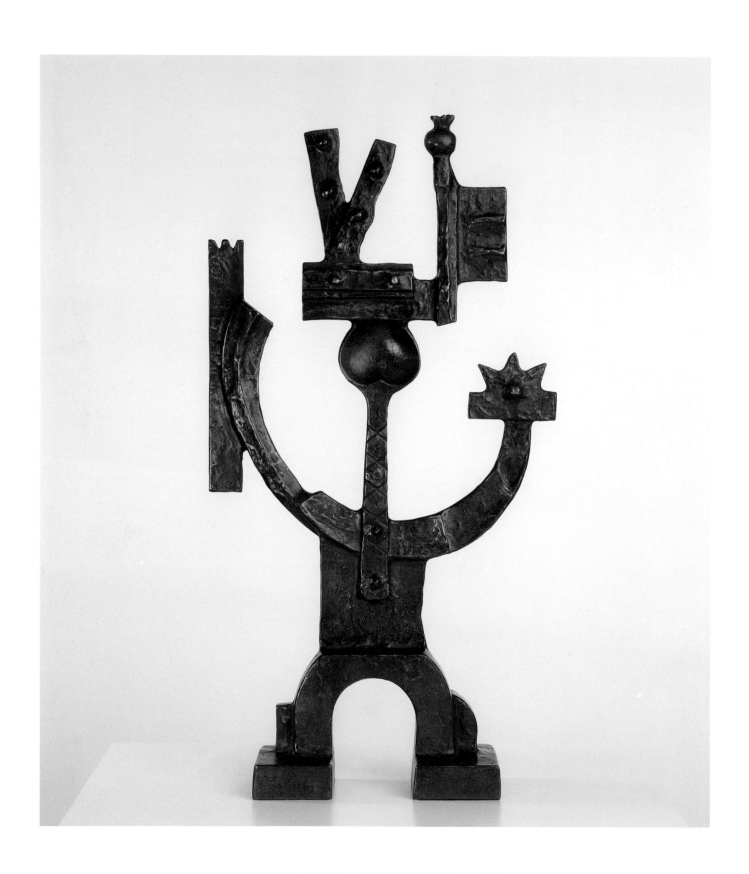

Holding Hope 1996 Bronze Cast. H 30" W 15 ½" D 4 ¼" (76 x 39 x 10.5 cm)
Sculpture No.223 (ED 9)

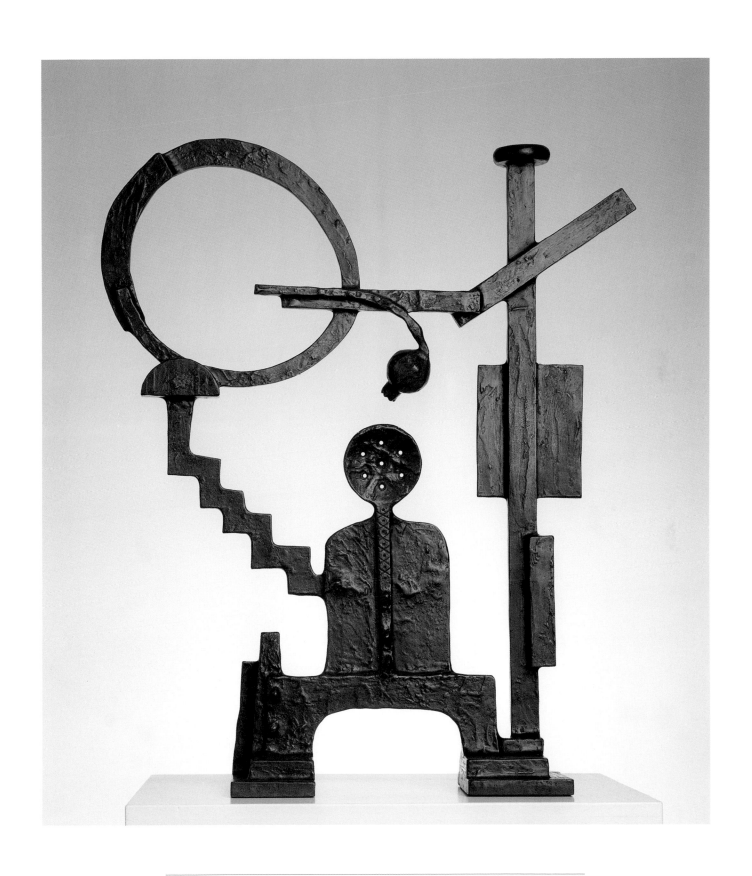

Peace in Circles 1996 Bronze Cast. H 34" W 28" D 6 ¾" (86 x 71 x 17 cm)
Sculpture No.224 (ED 5)

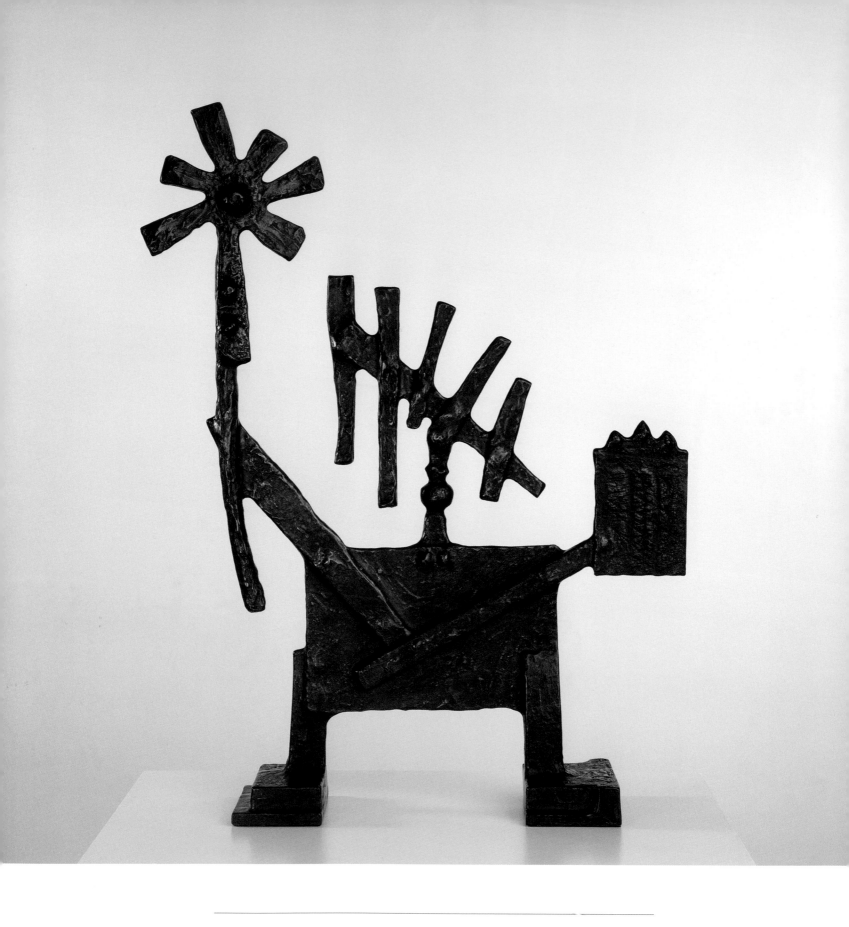

I Stand for Flowers 1996 Bronze Cast. H 30" W 25" D 6" (76 x 63 x 12.5 cm)
Sculpture No.225 (ED 9)

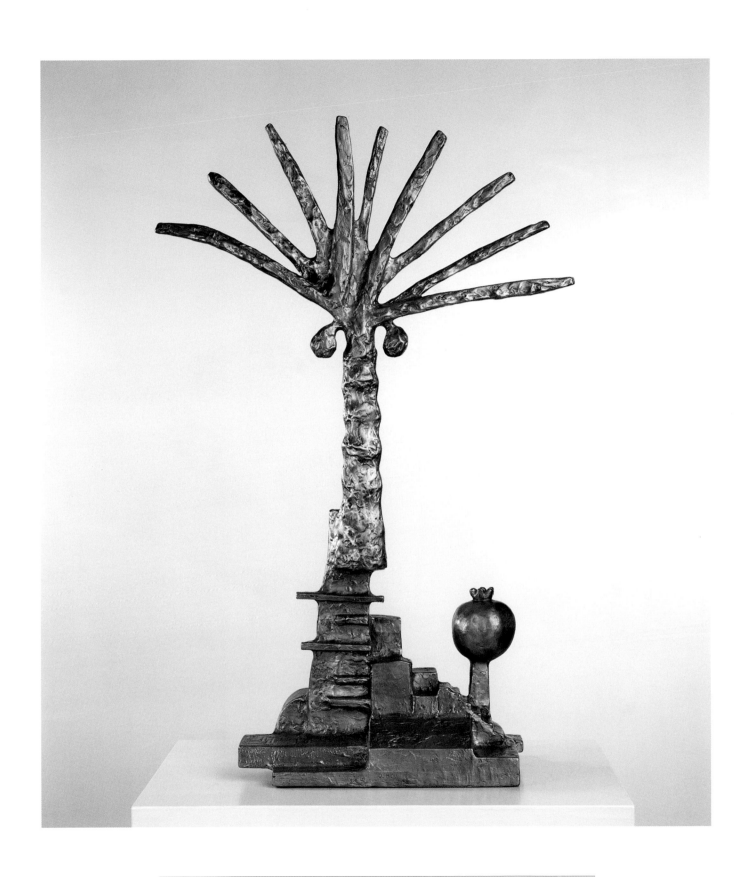

Conversation 1996 Aluminum Cast. H 36 ½" W 16 ¼" D 8 ¾" (92 x 41 x 22 cm)
Sculpture No.218 (ED 5)

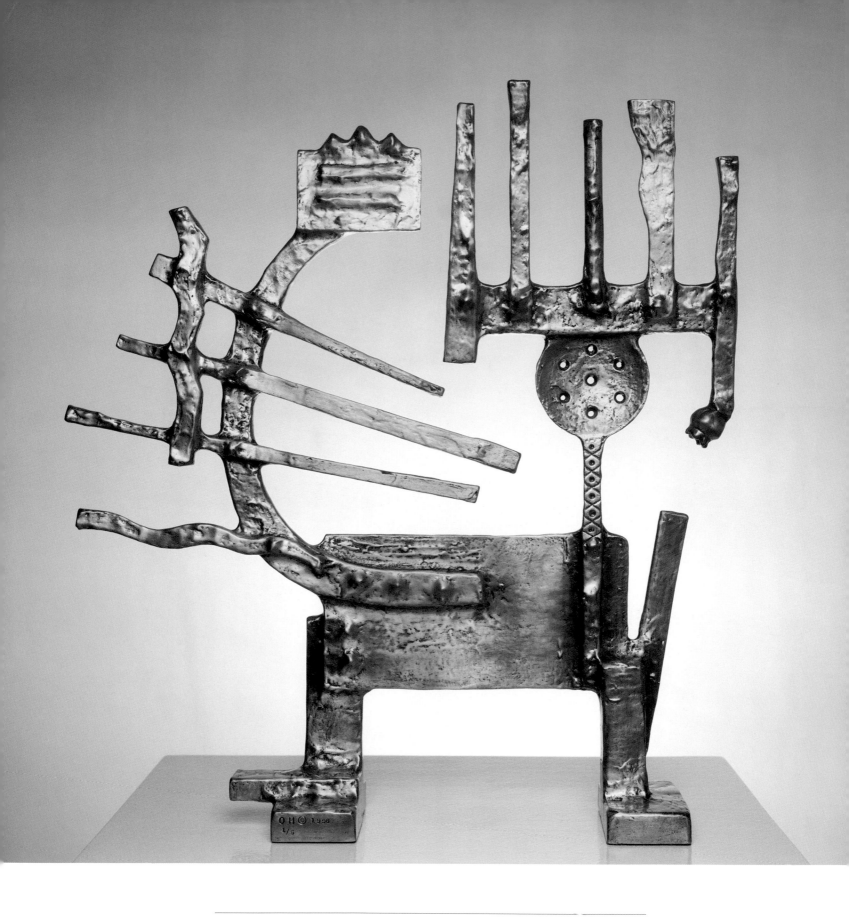

Sculptural Story 1996 Bronze Cast. H 26" W 22 ¾" D 5 ½" (66 x 58 x 14 cm)

Sculpture No.226 (ED 5)

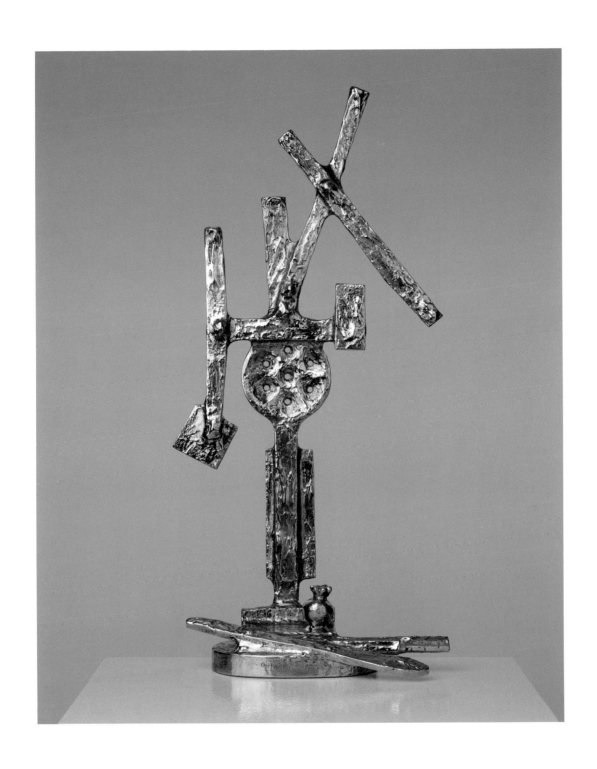

Abu Kifker 1997 Nickel Bronze Cast. H 27 ½" W 13 ½" D 6" (70 x 34 x 15 cm)
Sculpture No.231 (ED 9)

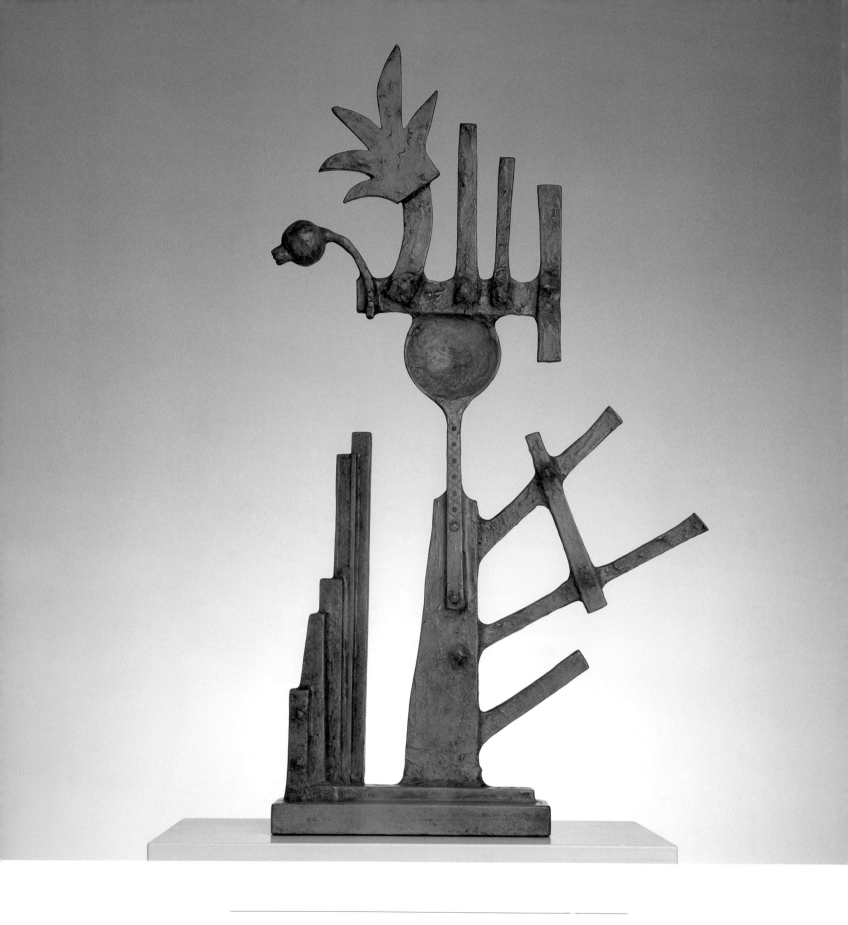

City in Bloom 1997 Bronze Cast. H 42" W 27" D 7" (107 x 69 x 18 cm)
Sculpture No.235 (ED 5)

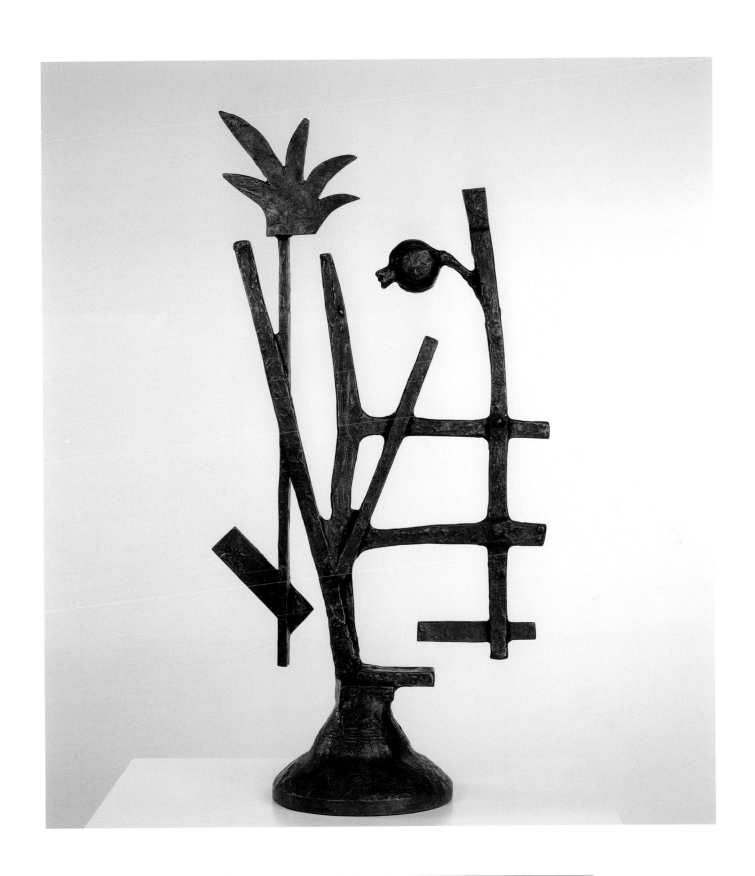

Ladder in Bloom 1997 Bronze Cast. H 35 ¾" W 18" D 9" (91 x 46 x 24 cm)
Sculpture No.233 (ED 5)

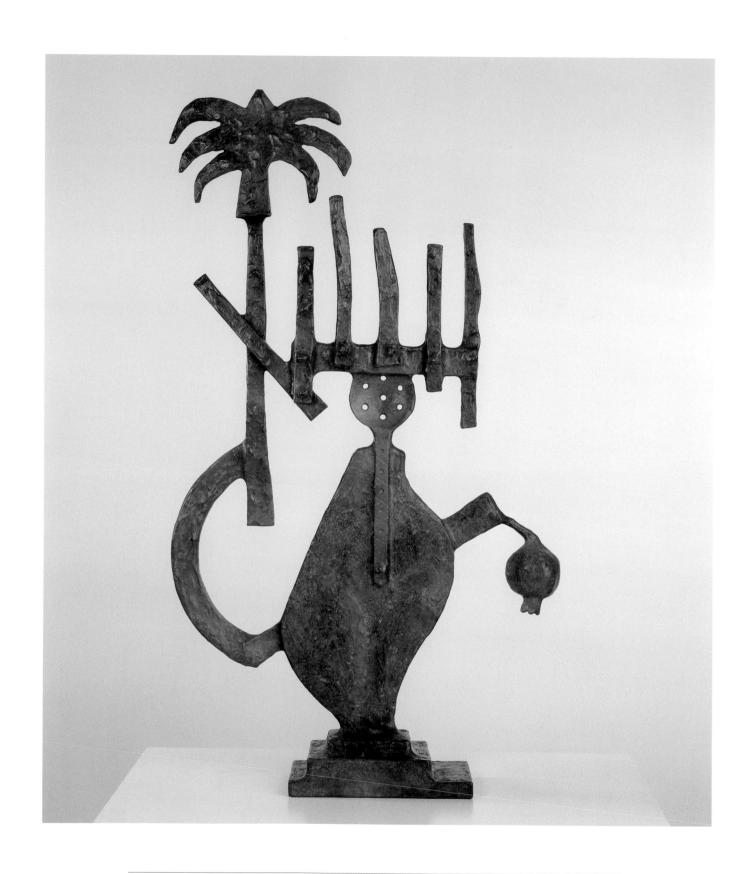

Lady with Wonderful Crown 1998 Bronze Cast. H 34" W 19" D 5 ¼" (86 x 48 x 13 cm)
Sculpture No.230 (ED 5)

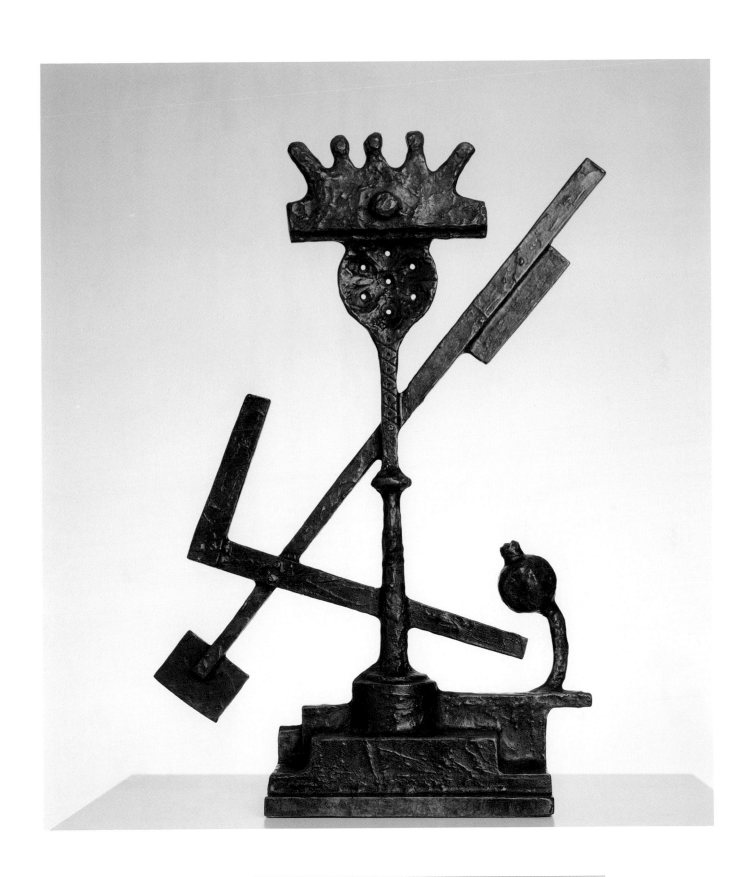

Peace Crossroads 1998 Bronze Cast. H 26 ½" W 18 ½" D 6 ¾" (67 x 47 x 17 cm)
Sculpture No.232 (ED 5)

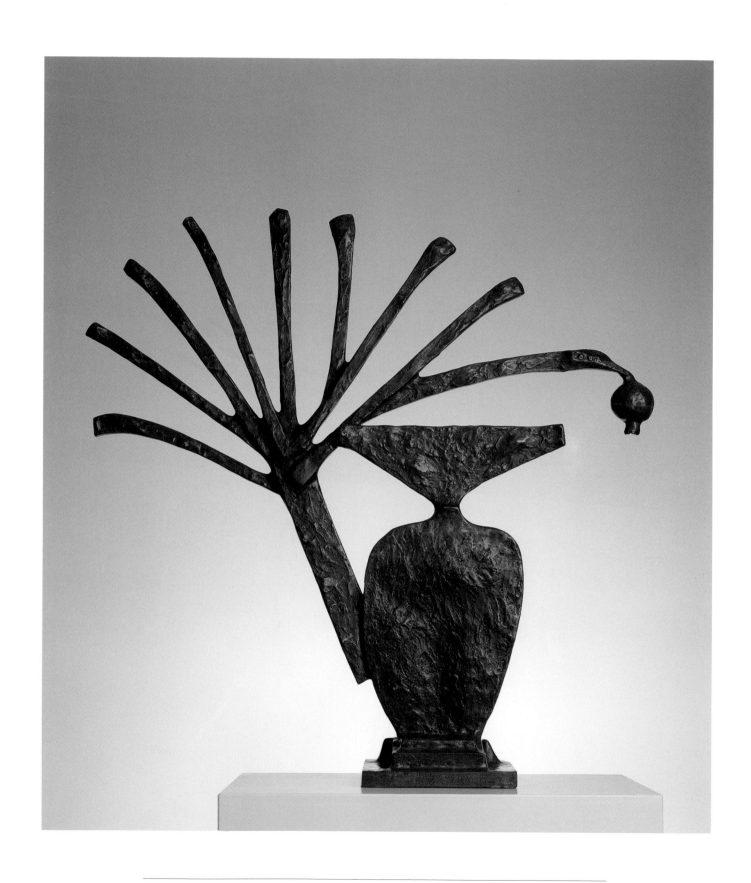

The Shelter of Peace 1998 Bronze Cast. H 37 ¼" W 37 ¼" D 9" (94 x 94 x 23 cm)
Sculpture No.229 (ED 5)

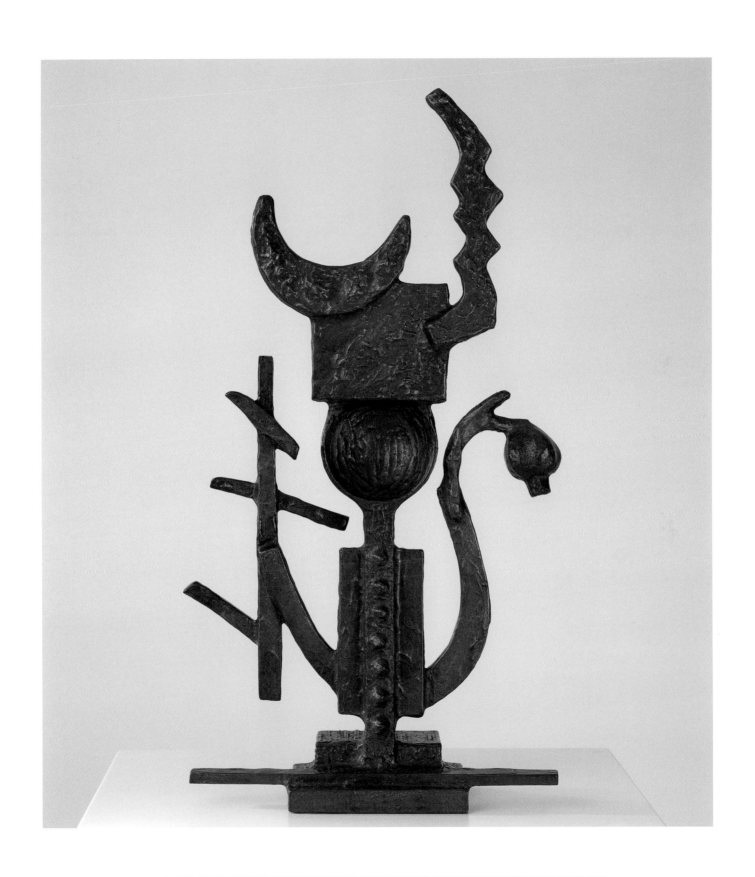

When Peace Comes 1999 Bronze Cast. H 30 ³/₈" W 16" D 5 ¼" (77 x 41 x 13 cm)
Sculpture No.237 (ED 5)

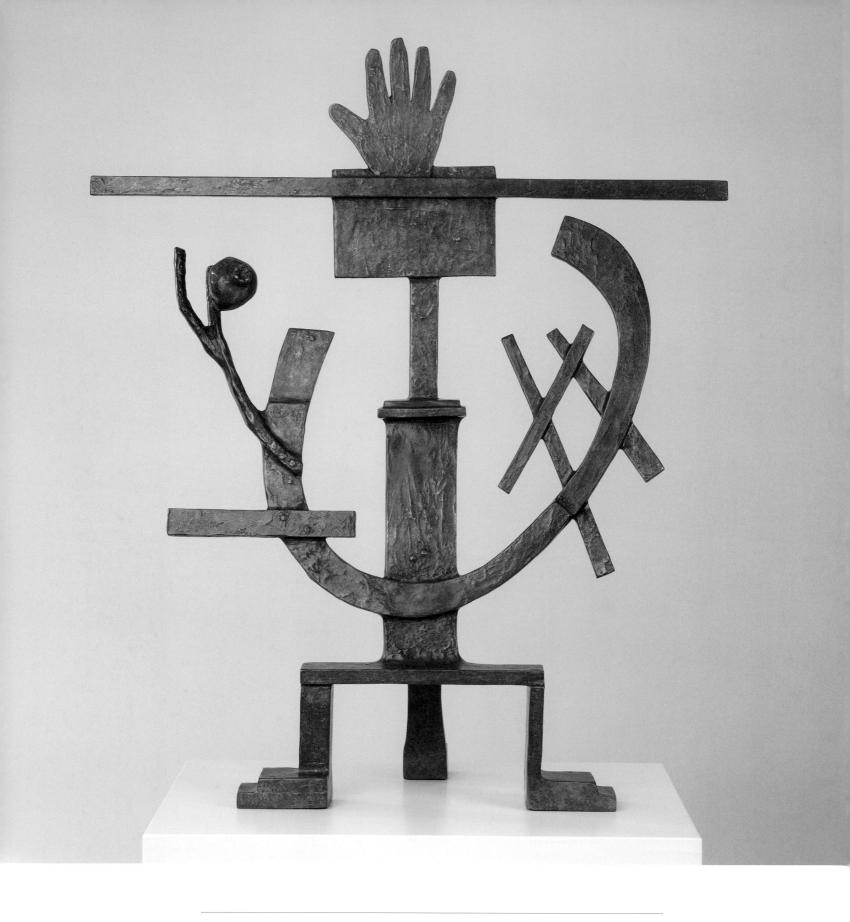

Stand Still and Dance 1999 Bronze Cast. H 38 ½" W 32" D 10" (98 x 82 x 25 cm)
Sculpture No.236 (ED 5)

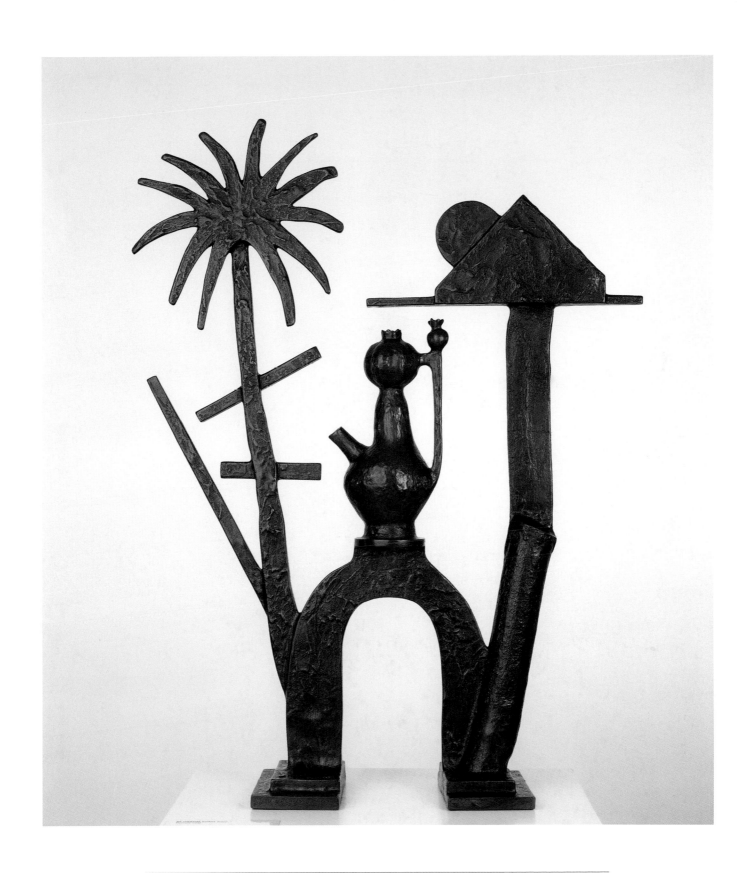

Stand Up For Peace 2000 Bronze Cast. H 39 ¼" W 29 ½" D 8 ¼" (99.5 x 75 x 21 cm)
Sculpture No.239 (ED 5)

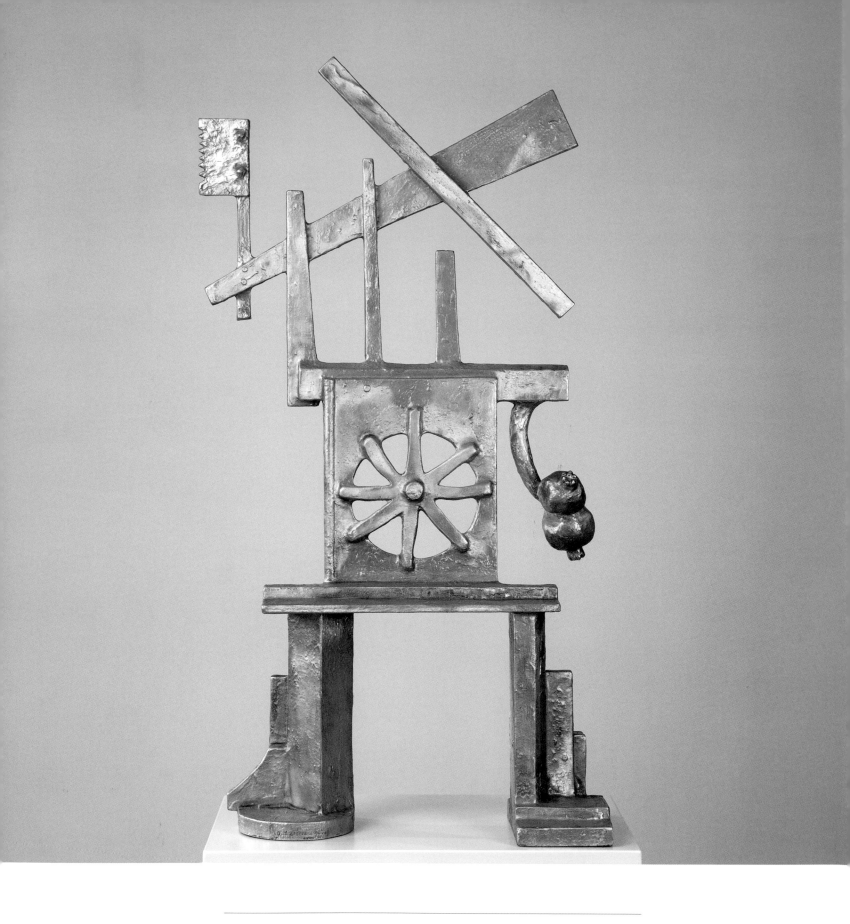

For The Twins 2000 Aluminum Cast. H 45" W 24" D 9" (114 x 61 x 23 cm)
Sculpture No.238 (ED 3)

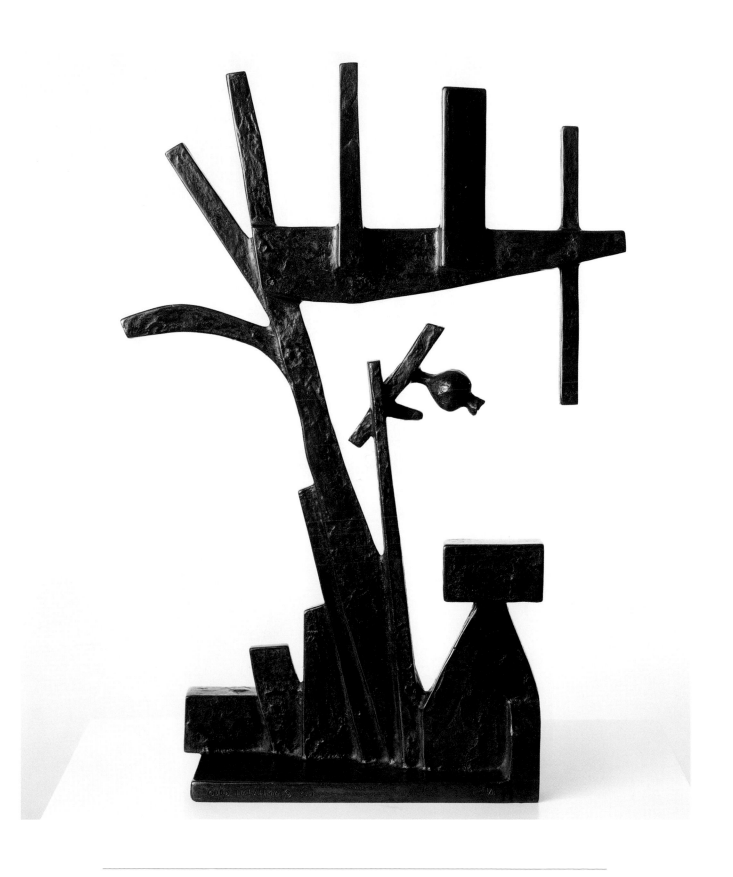

A Pomegranate For Peace 2001 Bronze Cast. H 27 ¼" W 19 ¼" D 5 ¼" (69 x 49 x 14 cm)
Sculpture No.241 (ED 5)

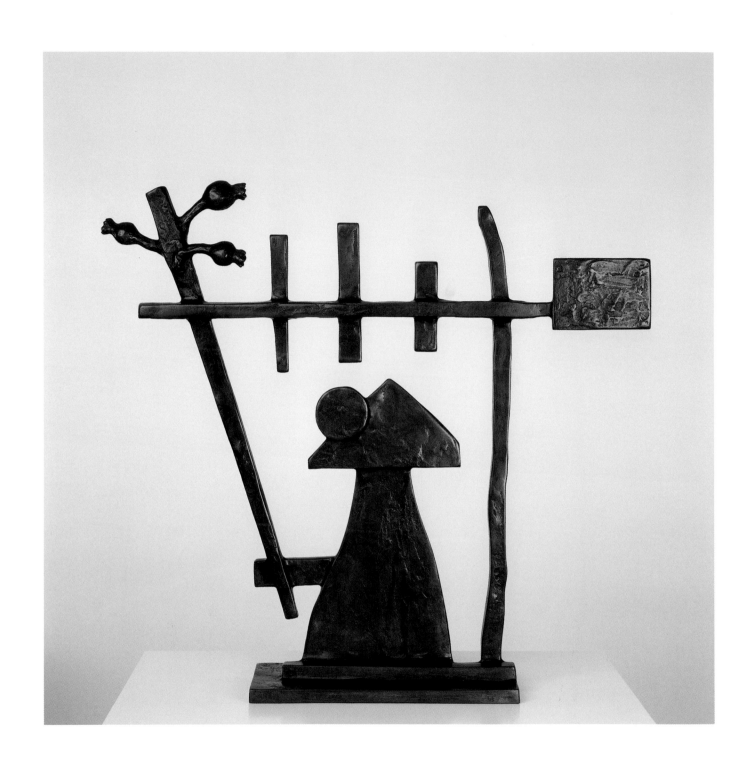

To Eat Pomegranate For Peace 2002 Bronze Cast. H 26" W 28" D 6" (66 x 71 x 15 cm)
Sculpture No.242 (ED 5)

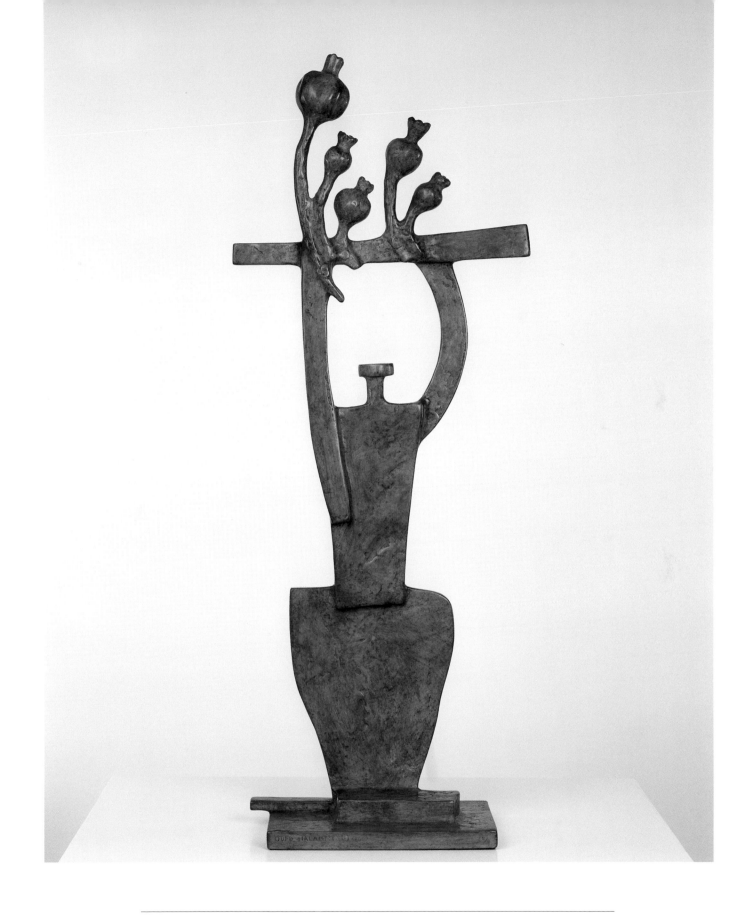

Proud Babylonian Lady 2002 Bronze Cast. H 34 ¼" W 13" D 6 ½" (87 x 33 x 16.5 cm)
Sculpture No.244 (ED 9)

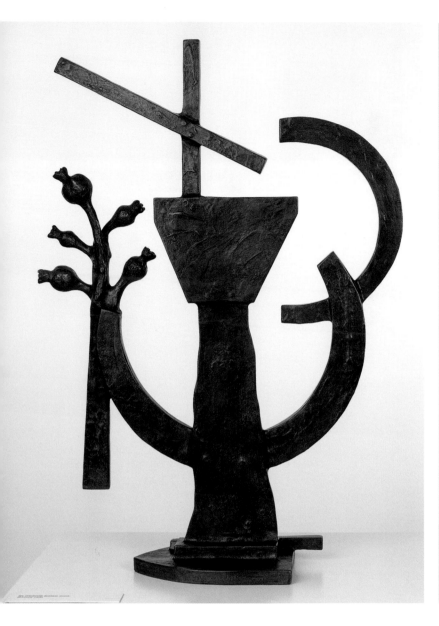

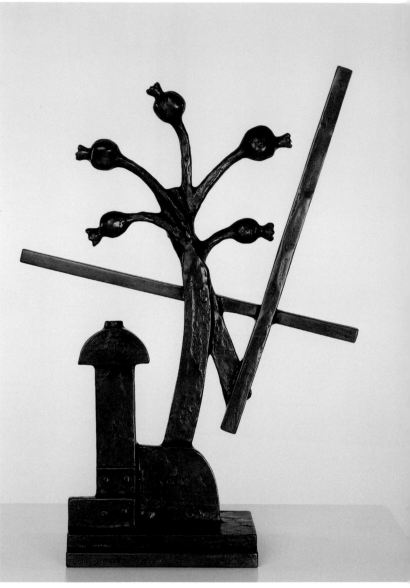

Left: **Blossom Song** 2002 Bronze Cast. H 30 ½" W 21 ½" D 8" (77.5 x 55 x 20 cm)
Sculpture No.243 (ED 5)

Right: **Coming Together** 2002 Bronze Cast. H 26 ½" W 19 ½" D 7 ½" (69 x 49.5 x 19 cm)
Sculpture No.245 (ED 5)

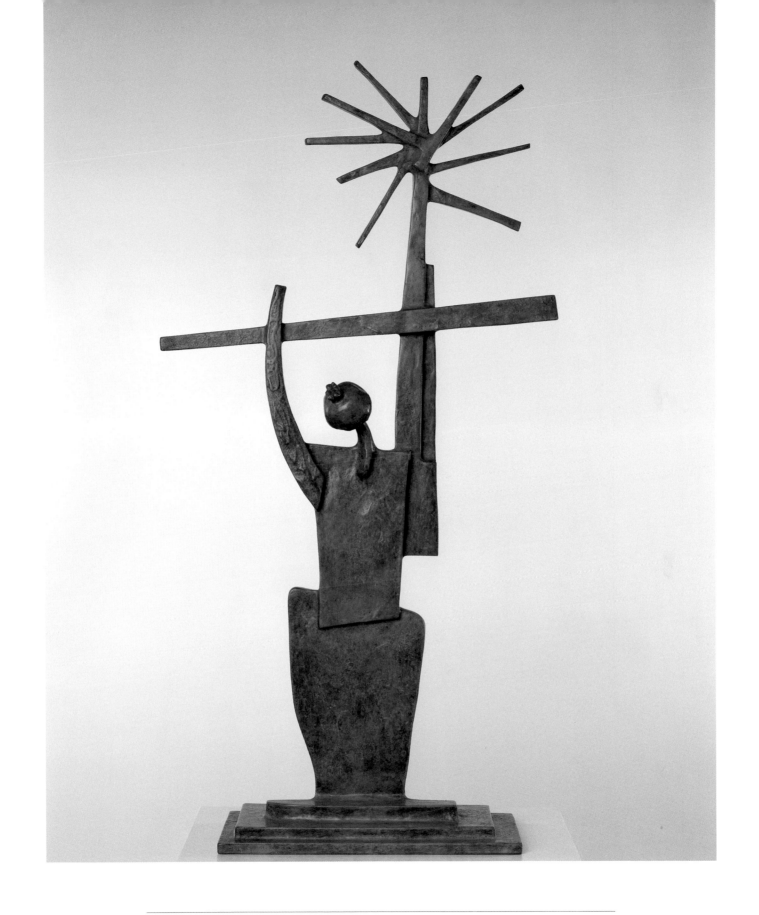

Imagining Peace 2003 Bronze Cast. H 48 ½" W 24 ½" D 8 ½" (123 x 108 x 21.5 cm)
Sculpture No.252 (ED 5)

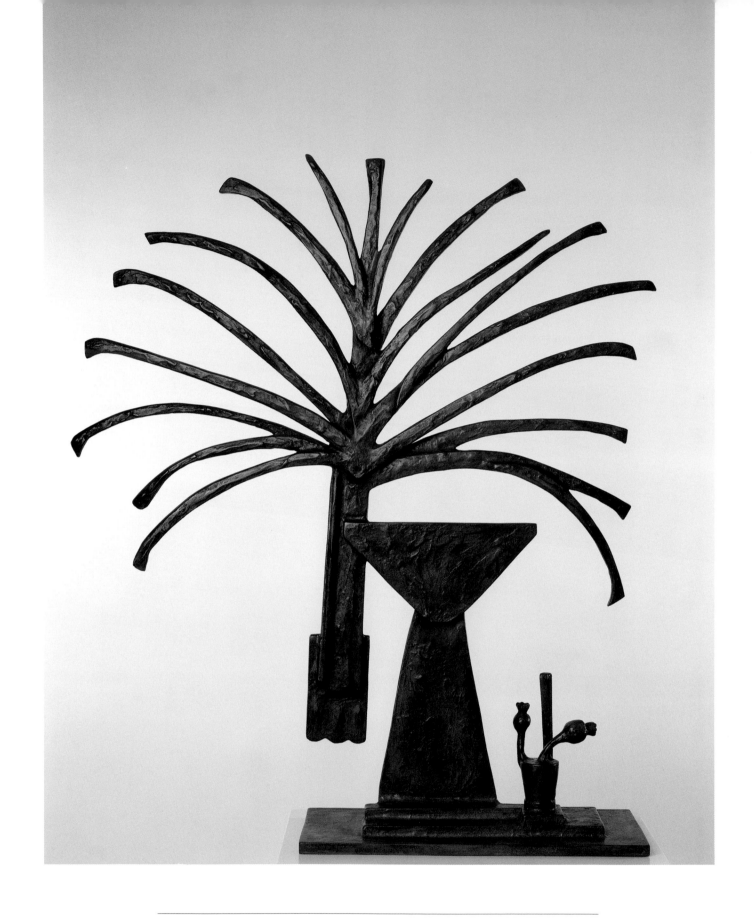

Flowering Song 2003 Bronze Cast. H 44 ½" W 37" D 10¾" (113 x 94 x 27 cm)
Sculpture No.251 (ED 5)

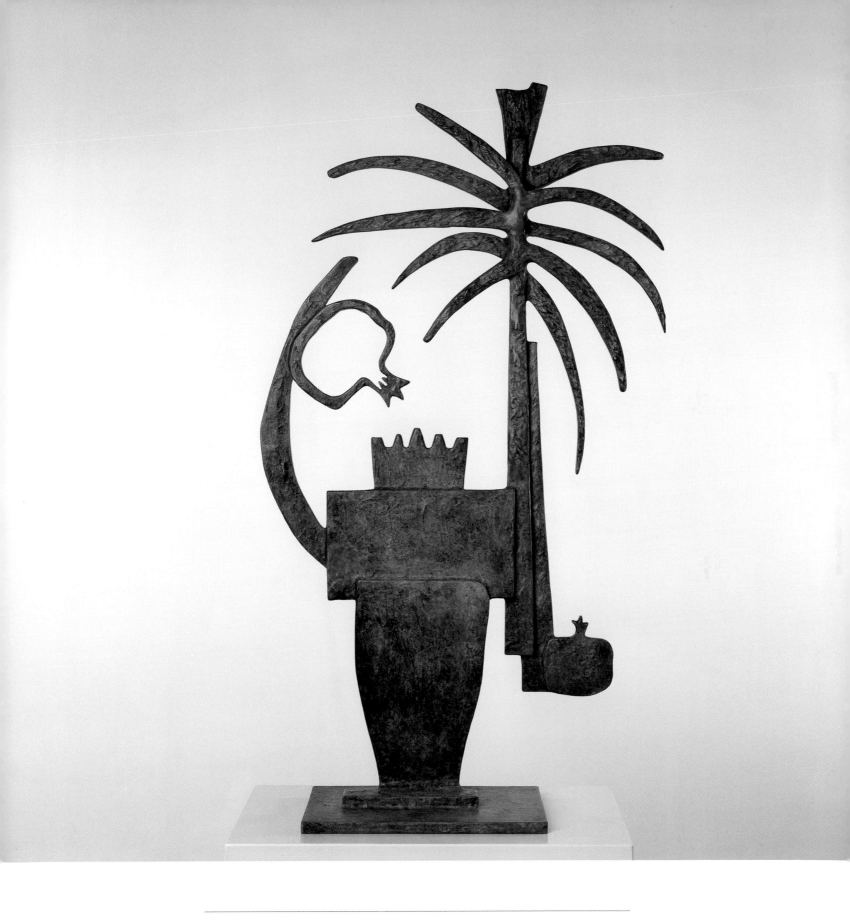

Drinking Juice 2003 Bronze Cast. H 46 ½" W 26" D 9 ⅞" (118 x 66 x 25 cm)
Sculpture No.250 (ED 5)

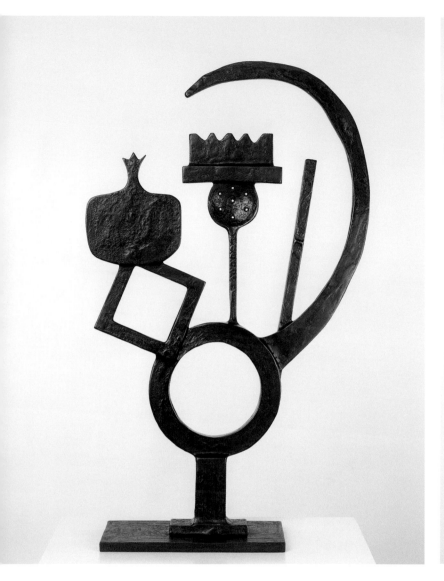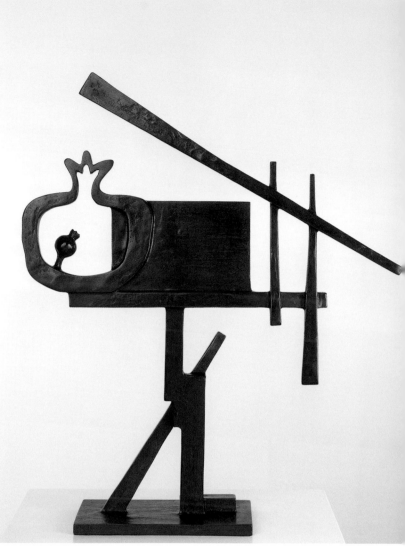

Left: **Where Did I Come From** 2003 Bronze Cast. H 36 ½" W 22" D 7 ½" (93 x 56 x 19 cm)
Sculpture No.249 (ED 5)

Right: **My Homeland is a Memory** 2003 Bronze Cast. H 32 ¾" W 27 ¾" D 7 ¼" (83 x 70 x 18 cm)
Sculpture No.247 (ED 9)

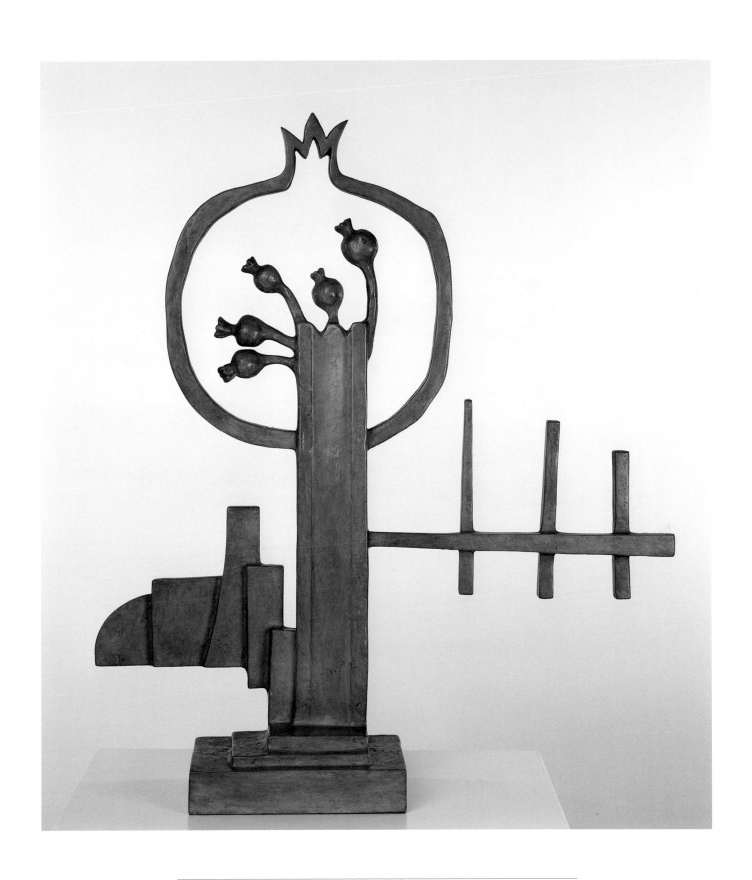

Peace Opening 2003 Bronze Cast. H 34" W 30" D 7" (86 x 76 x 18 cm)
Sculpture No.248 (ED 5)

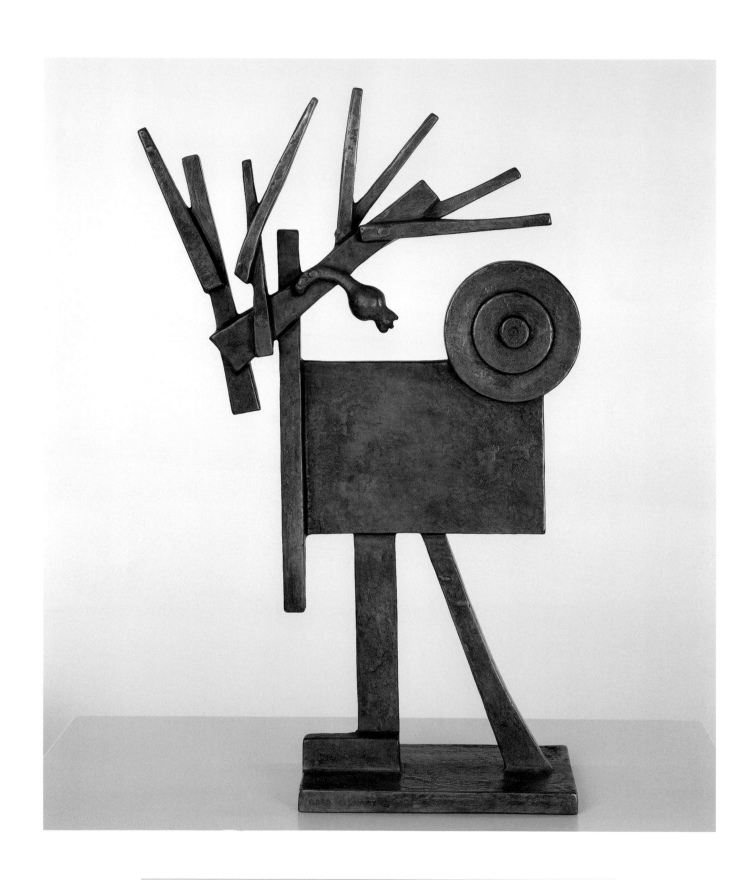

Flowering Hieroglyph 2003 Bronze Cast. H 23 ½" W 17 ½" D 6 ³⁄₈" (60 x 44 x 16 cm)
Sculpture No.246 (ED 9)

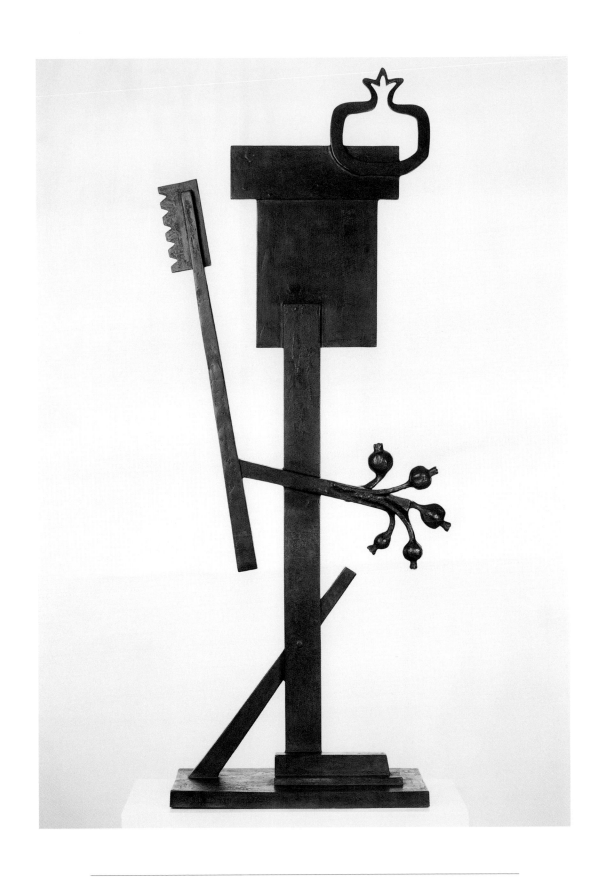

Walking Home 2003 Bronze Cast. H 70 ½" W 29" D 11 ¾" (179 x 73 x 30 cm)
Sculpture No.253 (ED 5)

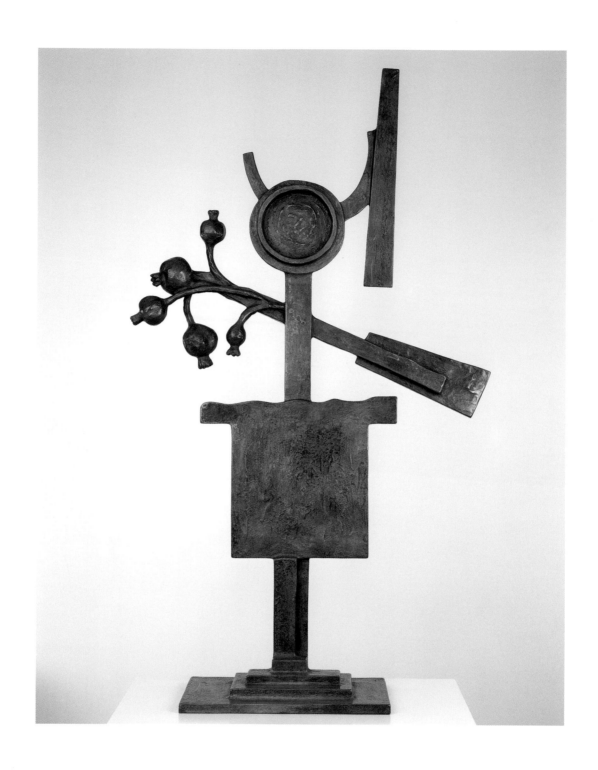

Wandering Home 2003 Bronze Cast. H 48" W 28 ½" D 10 ½" (122 x 72 x 26.5 cm)
Sculpture No.240 (ED 5)

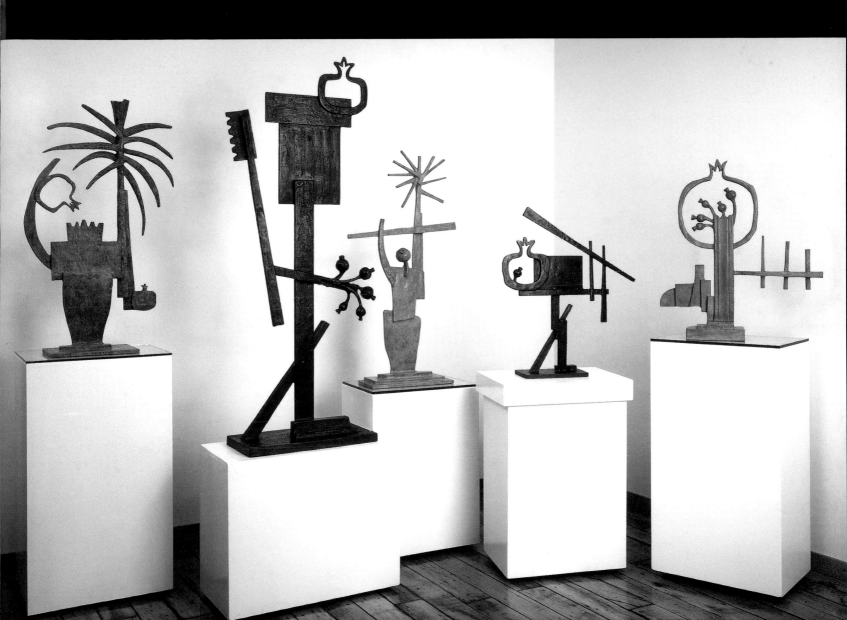

Chronology

ODED HALAHMY (C'HEBA'ZAH)

- Born in Baghdad, Iraq, 1938
- Immigrated to Israel, 1951
- Studied at St. Martin's School of Art, London, England, 1966-68
- Moved to Toronto, Canada, 1969
- Moved to New York City, U.S.A., 1971
- Currently living in New York City and in Old Jaffa, Israel.

TEACHING

- Ontario College of Art, Toronto, Canada, 1969-70
- Parsons School of Design, New York, New York, 1975-77

VISITING ARTIST

- Cooper Union Art School, New York University, New York Studio School, New School for Social Research, New York, New York

AWARDS

- Fellowship, Peter Samuel Foundation, London, England, 1967-68
- Fellowship, America-Israel Cultural Foundation, New York, New York, 1975

SELECTED ONE-MAN EXHIBITIONS

- Pollack Gallery, Toronto, Canada, 1968
- Old Jaffa Gallery, Jaffa, Israel, 1970
- Gallery Moos, Toronto, Canada, 1970
- Louis K. Meisel Gallery, New York, New York, 1974
- Herbert F. Johnson Museum of Art, Cornell University, Ithaca, New York, 1974
- Parsons School of Design, New York, New York, 1975
- Horace Richter Galleries, Jaffa, Israel, 1976
- Bicentennial Tribute, United States Federal Plaza, New York, New York, 1975-76
- Hebrew Union College, New York, New York, 1980
- New England Center for Contemporary Art, Brooklyn, Connecticut, 1981
- Louis K. Meisel Gallery, New York, New York, 1982
- Martha White Gallery, Louisville, Kentucky, 1982
- Tomasulo Gallery, Union County College, Cranford, New Jersey, 1983

- Aldrich Museum of Contemporary Art, Ridgefield, Connecticut, 1982-83
- Byer Museum of Art, Evanston, Illinois, 1984
- Louis K. Meisel Gallery, New York, New York, 1987
- Artists Studio, Old Jaffa, Israel, 1989
- Louis K. Meisel Gallery, New York, New York, 1991, 1993, 1997
- Louis K. Meisel Gallery, "In Retrospect: Sculpture from 1962-1997", New York, New York, 1997
- Sundaram Tagore Gallery, "The Common Ground", New York, New York, 2002
- Yeshiva University Museum, Homelands* Baghdad* Jerusalem* New York* A Retrospective, New York City, 2003

SELECTED GROUP EXHIBITIONS

- London Group, London, England, 1967
- Mayor Gallery, London, England, 1967
- Grosvenor Gallery, London, England, 1967
- Ben Uri Gallery, London, England, 1967
- Montreal Museum of Fine Arts, Montreal, Canada, 1968
- Tel Aviv Museum, Helena Rubinstein Pavilion, Tel Aviv, Israel, 1970
- Alwin Gallery, London, England, 1970
- One Hundred Acres Gallery, New York, New York, 1971
- American International Sculpture Symposium, New York, New York, 1972
- Horace Richter Galleries, Jaffa, Israel, 1973-86
- Queens Museum, Queens, New York, 1973
- International Sculpture Show, Gallery Moos, Toronto, Canada, 1974
- Ten from America International Sculpture Symposium, New York, New York, 1974
- Herbert F. Johnson Museum of Art, Cornell University, Ithaca, New York, 1974
- Gruenebaum Gallery, New York, New York, 1974
- Max Hutchinson Gallery, New York, New York, 1975
- Faculty Exhibition, Parsons School of Design, New York, New York, 1976, 1977
- Robert Elkon Gallery, New York, New York, 1976
- Bonino Gallery, New York, New York, 1976
- Alexander F. Milliken Gallery, New York, New York, 1977
- Monique Knowlton Gallery, New York, New York, 1977
- "Art for Collectors," Toledo Museum, Toledo, Ohio, 1978
- Aldrich Museum of Contemporary Art, Ridgefield, Connecticut, 1979
- Morgan Gallery, Shawnee Mission, Kansas, 1979
- Sid Deutsch Gallery, New York, New York, 1978-81
- Marisa Del Re Gallery, New York, New York, 1981
- Galerie Isy Brachot, Brussels, Belgium, 1982
- Louis K. Meisel Gallery, New York, New York, 10th Anniversary, 1983
- "The New Generation," Elaine Benson Gallery, Bridgehampton, New York, 1987
- Louis K. Meisel Gallery, New York, New York, 20th Anniversary, 1988
- Art in the Armory, New York, New York, 1988 Israel Museum, Jerusalem, Israel, 1989
- "The 79th Annual Exhibition," Maier Museum of Art, Randolph-Macon Woman's College, Lynchburg, Virginia, 1990
- Louis K. Meisel Gallery, New York, New York, 1990, 1993

- Hebrew Union College, New York, New York, 2001
- Sundaram Tagore Gallery, New York, New York, 2001
- Grinnell College, "Iraqi Art and Literature Around the World", Grinnell, Iowa, 2002
- DePaul University Art Gallery, "Iraqi Art Now", Chicago, Illinois, 2003

SELECTED MUSEUMS AND PUBLIC COLLECTIONS

- Solomon R. Guggenheim Museum, New York, New York
- Hirshhorn Museum and Sculpture Garden, Washington, D.C.
- Herbert F. Johnson Museum of Art, Cornell University, Ithaca, New York
- Indianapolis Museum of Fine Art, Indianapolis, Indiana
- Jewish Museum, New York, New York
- Chase Manhattan Bank, New York, New York
- Philbrook Museum of Art, Tulsa, Oklahoma
- Grand Rapids Art Museum, Grand Rapids, Michigan
- Israel Museum, Jerusalem, Israel
- Best Products Company, Inc., Richmond, Virginia
- Prudential Insurance Company, San Francisco, California
- Danville Museum of Fine Arts and History, Danville, Virginia
- Hebrew Union College, New York, New York
- Hebrew Union College, Jerusalem, Israel
- Tomasulo Gallery, Union County College, Cranford, New Jersey
- Marietta/Cobb Museum of Art, Marietta, Georgia
- Erie Art Museum, Erie, Pennsylvania

- Peter Samuel Foundation, London, England
- Hudson River Museum of Westchester, Yonkers, New York
- New Jersey State Museum, Trenton, New Jersey
- Fine Arts Museum of Long Island, Hempstead, New York
- New England Center for Contemporary Art, Brooklyn, Connecticut
- University of Tennessee, Knoxville, Tennessee
- Hofstra Museum, Hempstead, New York
- Aldrich Museum of Contemporary Art, Ridgefield, Connecticut
- Chicago Athenaeum, Chicago, Illinois
- Tucson Museum of Art, Tucson, Arizona
- Macalester College, St. Paul, Minnesota
- Neuberger Museum of Art, SUNY at Purchase, Purchase, New York
- Butler Institute of American Art, Youngstown, Ohio
- Discount Bank, New York, New York
- Center for the Arts, Vero Beach, Florida
- SUNY Potsdam, Potsdam, New York
- Art Gallery of Hamilton, Hamilton, Ontario, Canada
- Sloan's Curve, Palm Beach, Florida

SELECTED BIBLIOGRAPHY

- World Sculpture News, 2003
- Sun, 25 August, 2003
- New York Times, 23 March, 2003
- ART news, January 1998
- New York Living, July 1996
- Fine Arts Review, 1994
- Sentinel-Record, Hot Springs, Arkansas, 24 November 1994
- New York Times, 17 December 1992

- Who's Who in American Art, 1989

- New York Art Review, Les Krantz, 1988

- American Art Galleries, Les Krantz, 1985

- Evanston Review, Michael Bunestell, 14 June 1984

- New York Times, 3 April 1983

- Ridgefield Press, 23 October 1982

- Italian Vogue, Daniela Morera, October 1982

- Ridgefield Press, 29 December 1981

- Hartford Courant, Art Review, 2 August 1981

- Palm Beach Daily News, 18 February 1981

- Pictures on Exhibit, September-October 1980

- ArtSpeak, Peter Fingestein, 25 September 1980

- SoHo Weekly News, John Perreault, 4-10
 August 1977

- Jerusalem Post, Gil Goldfine, 20 August 1976

- WPIX TV Show, 22 October, 11:00 a.m., 1975

- Tarbut, Irene Shapiro, Spring 1975

- Arts Magazine, Noel Frackman, May 1974

- SoHo Weekly News, Peter Frank, p.14,
 7 March 1974

- New York Times, James R. Mellow, 9 May 1973

- Art International, April Kingsley, February 1973

- ART news, Margaret R. Weiss, December 1972

- ART news, Gerrit Henry, December 1972

- Arts Magazine, Laura Sue Schwartz,
 November 1972

- Art Canada, Peter Norton, April 1970

- Globe and Mail, Toronto, Canada, Kay Kritzwiser,
 February 1970

- Globe and Mail, Toronto, Canada,
 28 September 1968

- La Presse, Montreal, Canada, 4 September 1968

- Arts Review, Cotie Burland, 27 May 1967

- Arts Rev Laughton, 19 February 1967

Marius Kwint was born in Sacramento in 1965, and brought up both in the Netherlands and in England, where his father, a naturalized Dutch-American, worked as a schoolteacher on U.S. Air Force bases. He studied art and cultural history at the University of Aberdeen, in Scotland, before writing his doctorate on the history of the eighteenth-century English circus at Magdalen College, University of Oxford. Dr. Kwint has held fellowships at the Houghton Library, Harvard University and at the Royal College of Art and the Victoria and Albert Museum, London. He is currently a fellow of St. Catherine's College and a lecturer in the History of Art at the University of Oxford. His publications include *Material Memories: Design and Evocation* (1999), and "The Circus in Georgian England," which appeared in the Feburary 2002 edition of the leading historical journal *Past and Present*. In his spare time, he attempts to pursue an avid interest in skiing and triathlon.

Donald Kuspit is an art critic and a professor of art history and philosophy at the State University of New York at Stony Brook. He received the 1997 Lifetime Achievement Award for Distinguished Contribution to Visual Arts from the National Association of Schools of Art and Design. He is a 1983 recipient of the College Art Association's prestigious Frank Jewett Mather Award for Distinction in Art Criticism. He is a contributing editor at *Artforum, Sculpture,* and *New Art Examiner* magazines, the editor of *Art Criticism*, and the editor of a series on American Art and Art Criticism for Cambridge University Press. He has been awarded fellowships from the Ford Foundation, the Fulbright Commission, the National Endowment for the Humanities, the National Endowment for the Arts, and the Guggenheim Foundation, among others. An author of numerous articles, exhibition reviews, and catalog essays, Kuspit has written more than twenty books, including *Redeeming Art: Critical Reveries* (Allworth Press), *Daniel Brush, Joseph Raffael, Chihuly*, and *Idiosyncratic Identities: Artists at the End of the Avant-Garde*. He lives in New York City.

Michaël J. Amy is a critic and art historian, with a Ph.D. from New York University's Institute of Fine Arts. He is currently an Assistant Professor of Art History in the College of Imaging Arts & Sciences at Rochester Institute of Technology. He has published numerous articles and exhibition reviews in newspapers, magazines and scholarly publications, including *The New York Times, The New York Sun, Art in America, Art & Antiques, The Burlington Magazine, Apollo, Sculpture and tema celeste*. Michaël Amy lives and works in New York City and Rochester.